LEFT FIELD, RELOADED

More Cartoons
by
Randy Halford

authorHOUSE®

AuthorHouse™
1663 Liberty Drive
Bloomington, IN 47403
www.authorhouse.com
Phone: 1-800-839-8640

First published by AuthorHouse 02/23/2010

ISBN:978-1-4490-7503-3 (sc)
ISBN:978-1-4490-7504-0 (e)

Library Congress Number:2010901345

Printed in the United States of America
Bloomington, Indiana

This book is printed on acid-free paper.

THANKS...

To AuthorHouse for helping me through my sophomore book.

To those who have read my first book, and urged me to do a second one (as if I could ever refuse!).

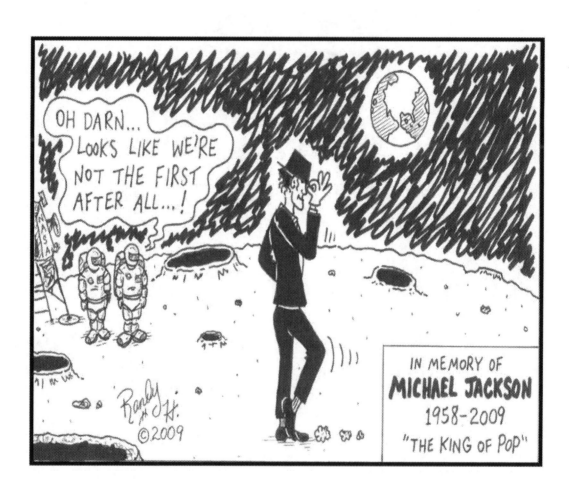

"If 'Seinfeld' is a television show about nothing, then 'Left Field' are cartoons about everything else."
 —Randy Halford

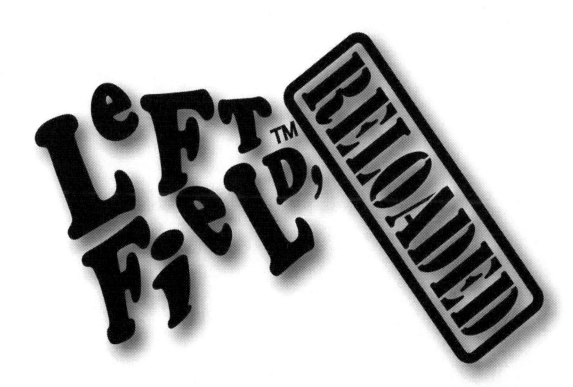

More Cartoons by RANDY HALFORD

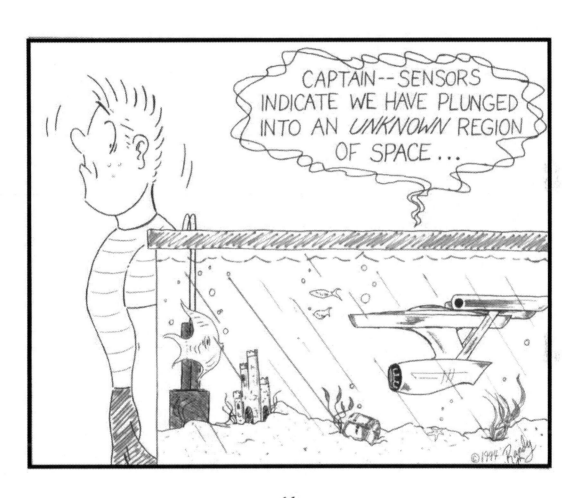

1

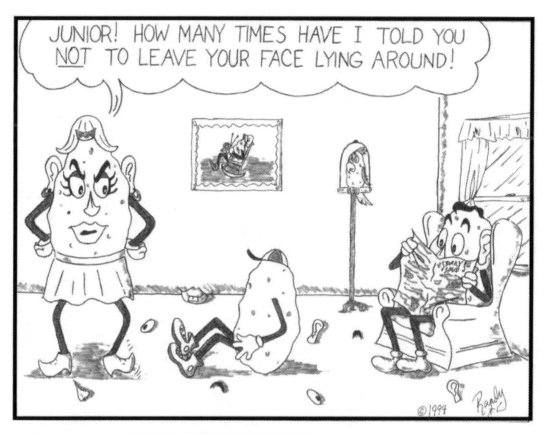

THE POTATOHEADS AT HOME

2

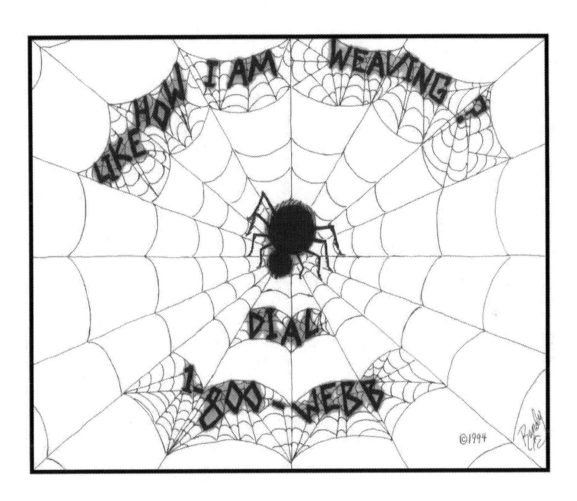

3

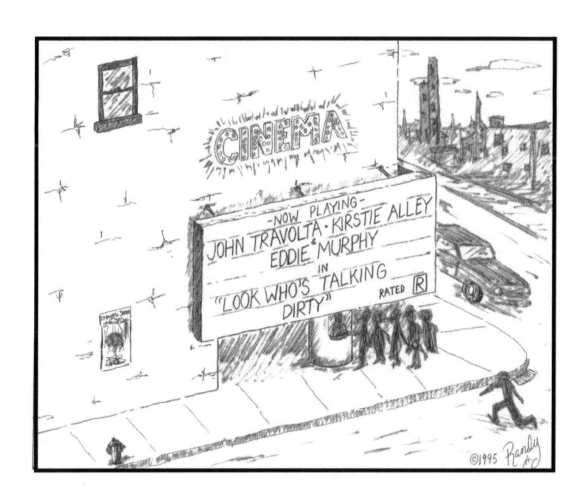

4

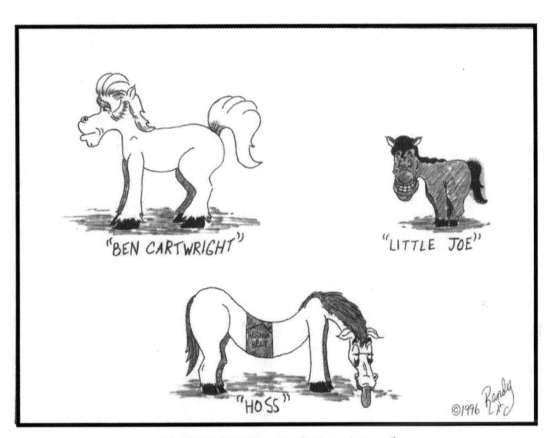

THE HORSES OF "BONANZA"

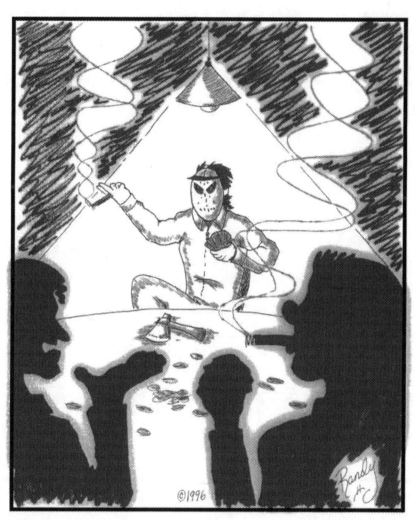

"..DANGIT, JASON! WE CAN NEVER TELL
WHEN YOU'RE BLUFFIN'..."

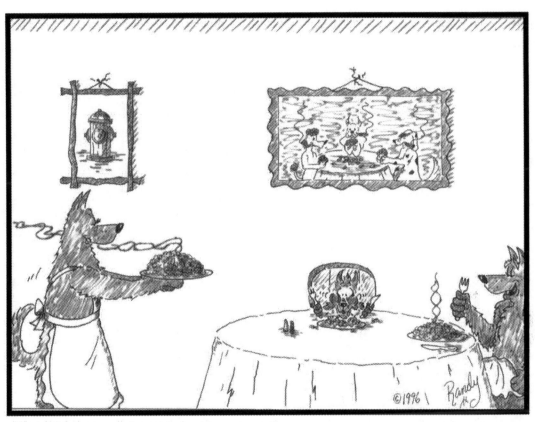

"CAREFUL THERE, SON—DON'T WOOF DOWN YOUR FOOD."

7

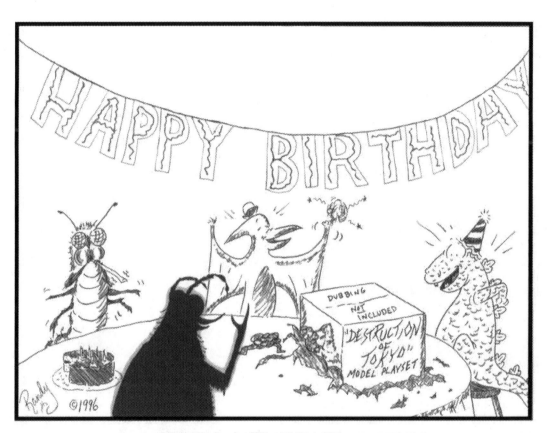

GODZILLA: THE EARLY YEARS

8

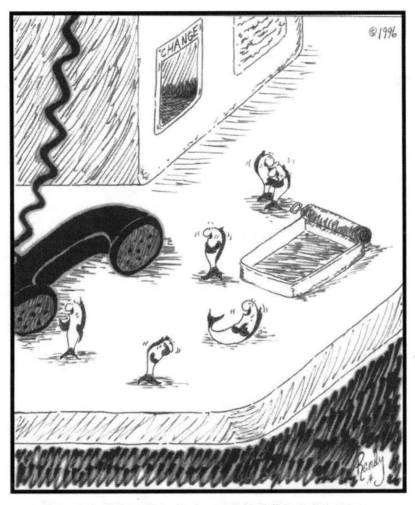

"..HELLO? KELSEY'S MARKET? DO YOU
HAVE SARDINES IN A CAN? WELL, PLEASE
LET 'EM OUT--THEY'RE COUSINS OF MINE..."

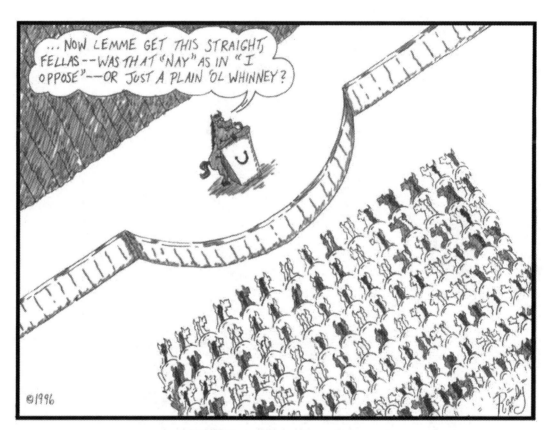

HORSE MEETINGS

10

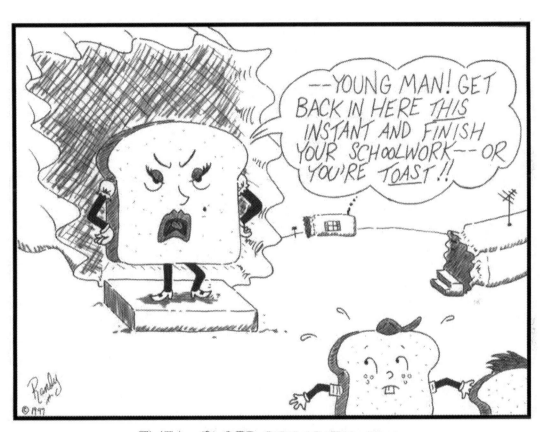

THE WONDER BREAD FAMILY

11

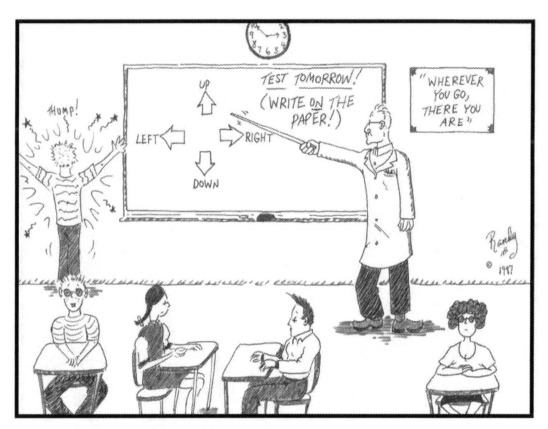

SCHOOL FOR THE MIS-DIRECTED

12

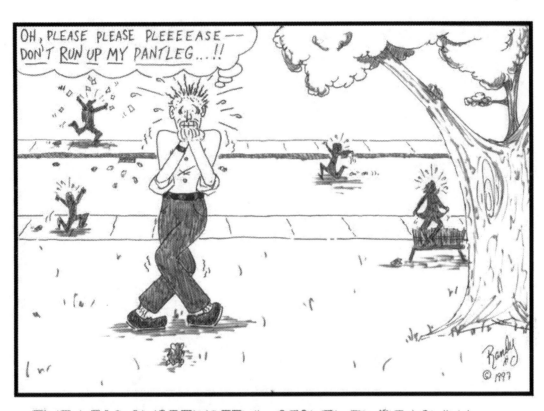

THE LESS-SUSPENSEFUL SEQUEL TO "ARACHNA-
PHOBIA"—"GERBILPHOBIA"...

13

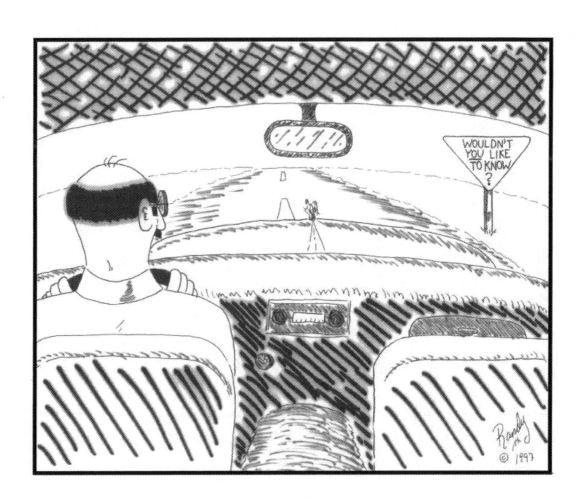

14

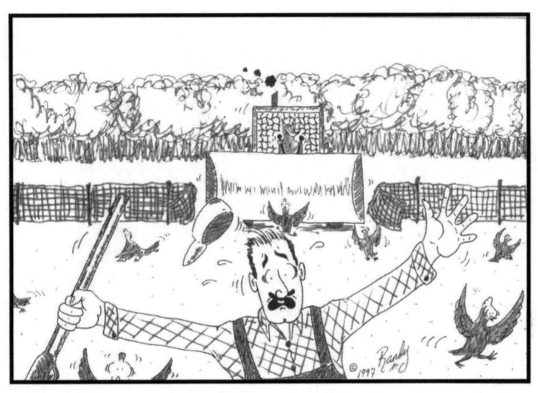

TIRED OF BEING A "SLY" FOX, AXEL DECIDES TO TAKE THE DIRECT APPROACH...

15

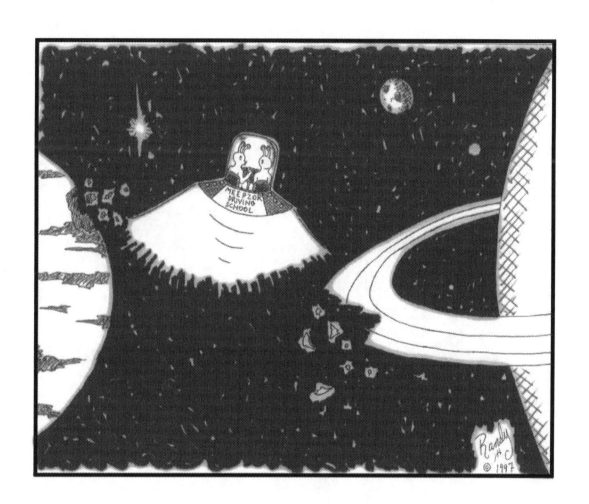

16

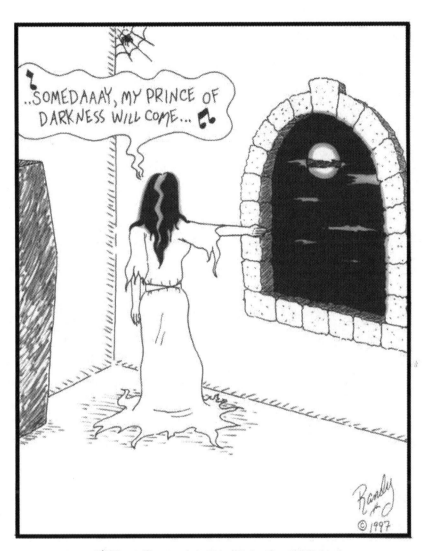

"DRACULA: THE MUSICAL"

17

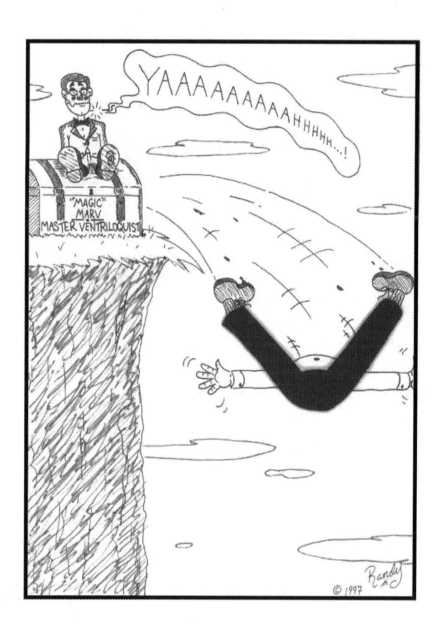

18

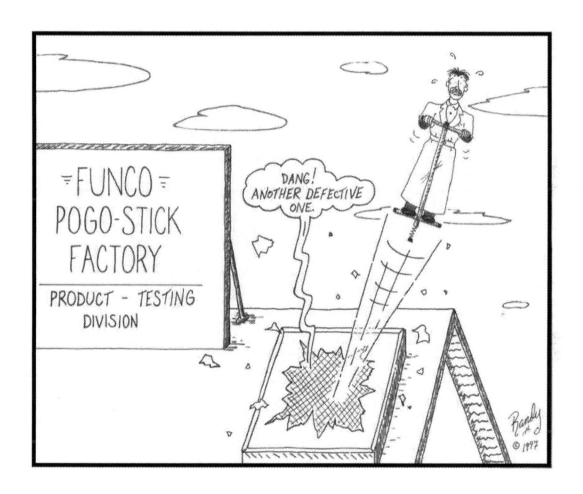

19

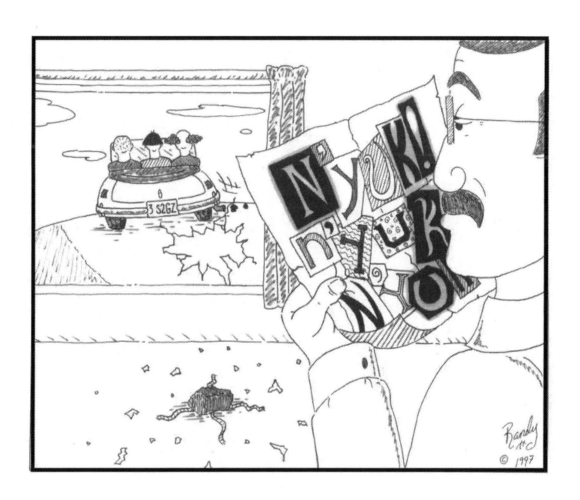

20

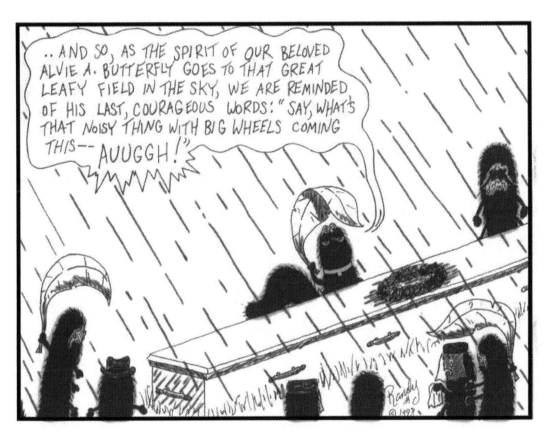

CATERPILLAR FUNERALS

21

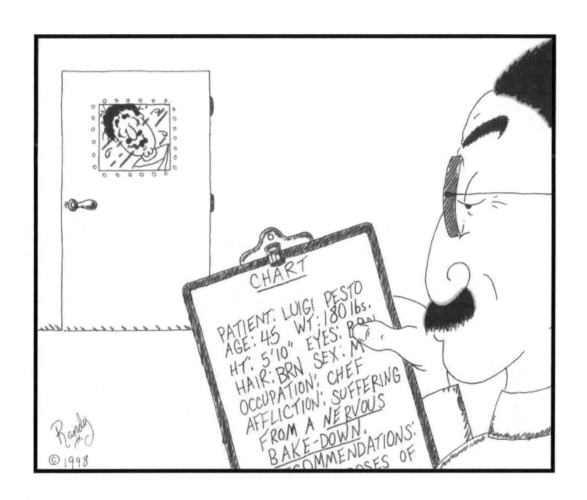

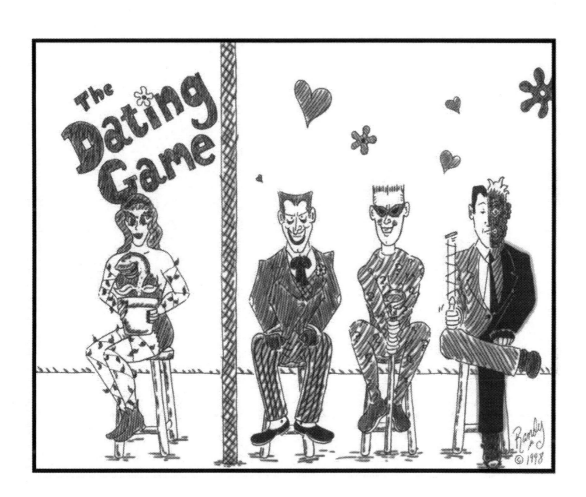

23

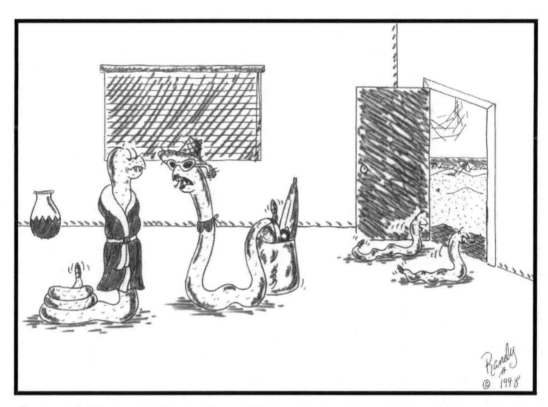

"OH, STOP WORRYING, HERB, AND COME ENJOY THE SUN! IT'S NOT AS IF YOU WON'T PEEL EVENTUALLY!"

24

THE INNER-CITY PUNKS SOON REGRETTED THEIR
DECISION TO DEFACE THE FAMOUS "HEE-HAW" FENCE...

25

FLEA INSULTS

26

LUKE SKYWALKER'S CHILDHOOD

27

WHEN THE WICKED WITCH CLEANS HOUSE

28

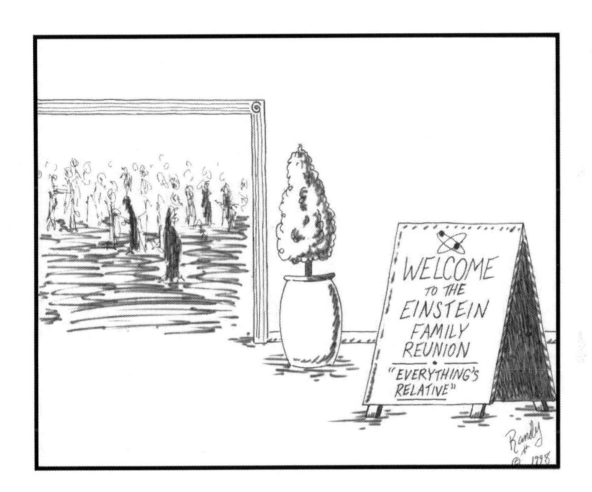

29

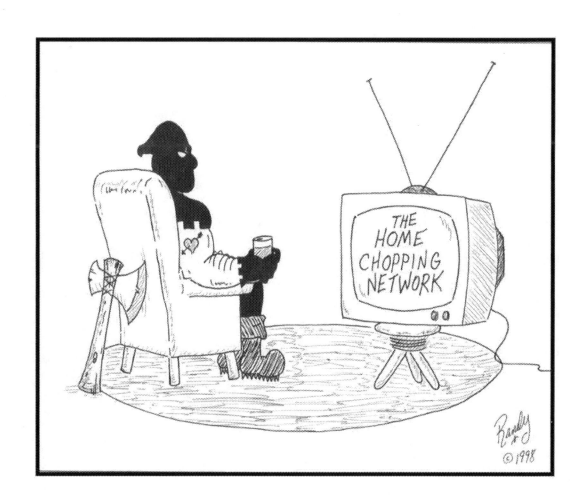

30

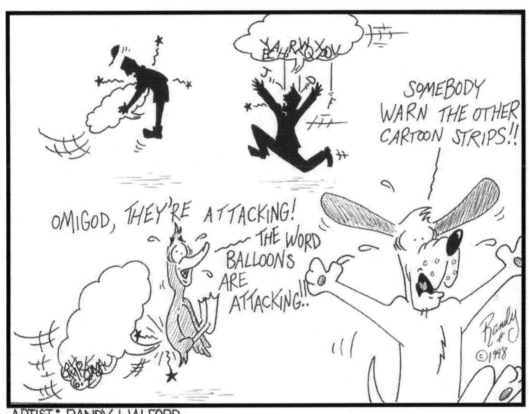

ARTIST: RANDY HALFORD
TITLE: I WAS IN A REALLY WEIRD MOOD; SO SUE ME.

31

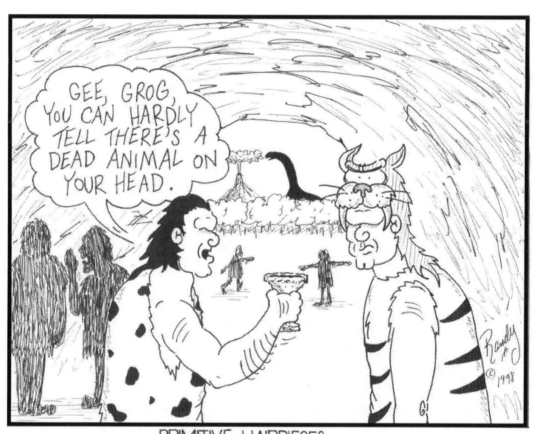

PRIMITIVE HAIRPIECES

32

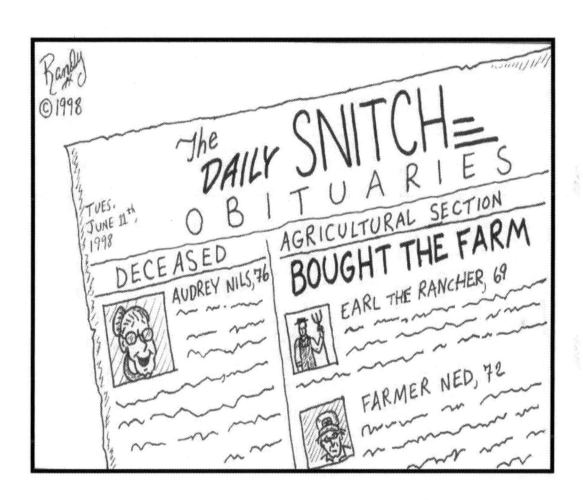

33

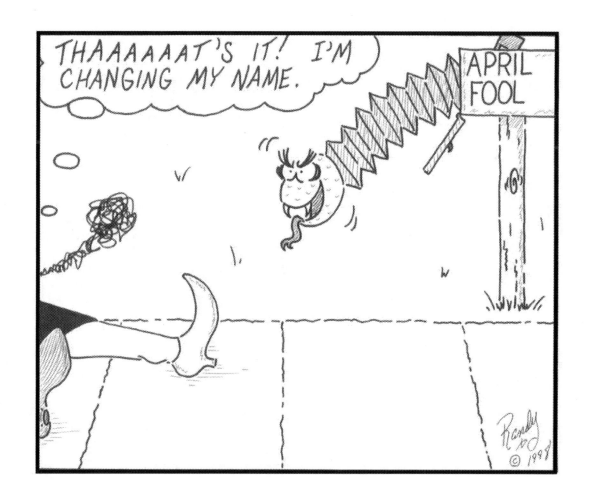

34

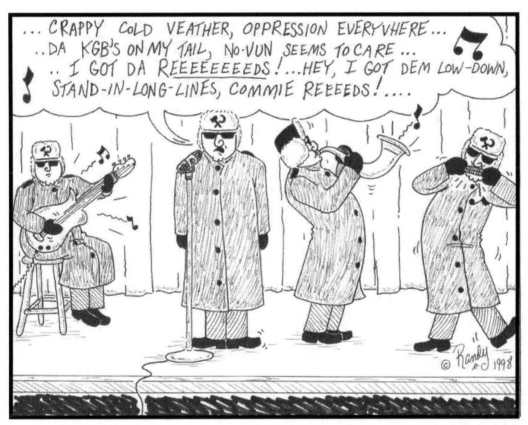

FROM THE OLD IRON CURTAIN DAYS: THE RUSSIAN BLUES

35

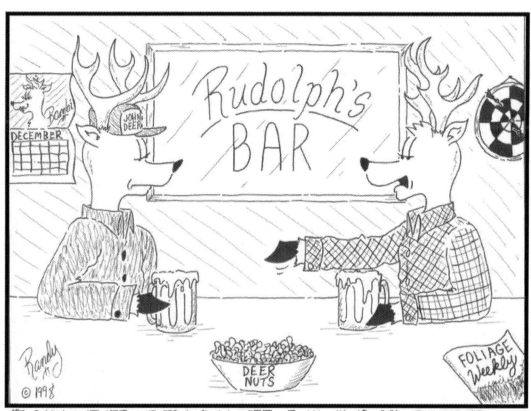

"I CAN NEVER LIE TO MY WIFE. I ALWAYS COME HOME WITH THAT 'HUMAN-CAUGHT-IN-THE-HEADLIGHTS' LOOK".

36

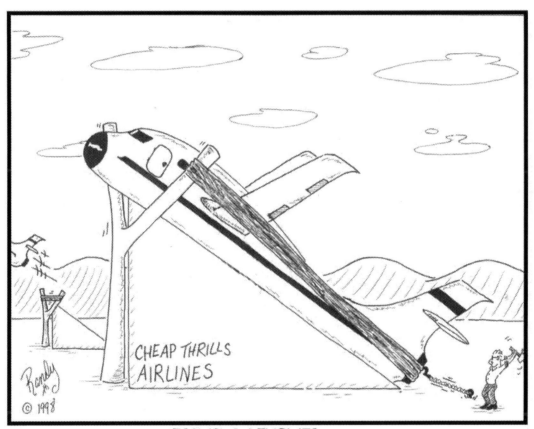

ECONOMY FLIGHTS

37

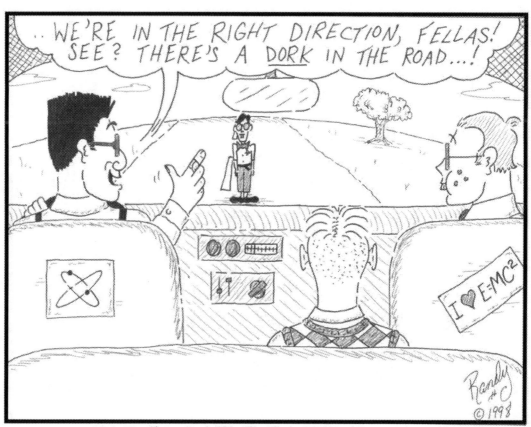

ON THE WAY TO THE NERD CONVENTION

38

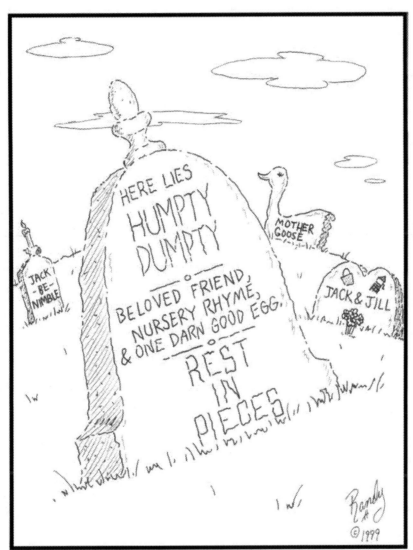

HUMPTY'S EPITAPH

39

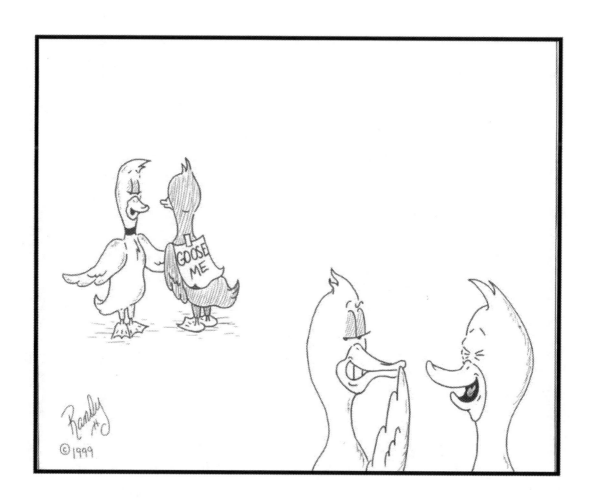

40

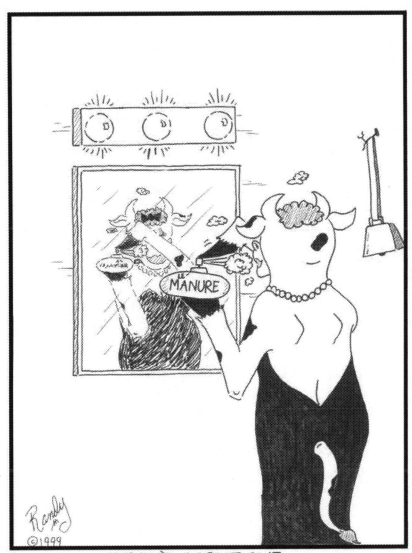

BESSIE'S NIGHT OUT

41

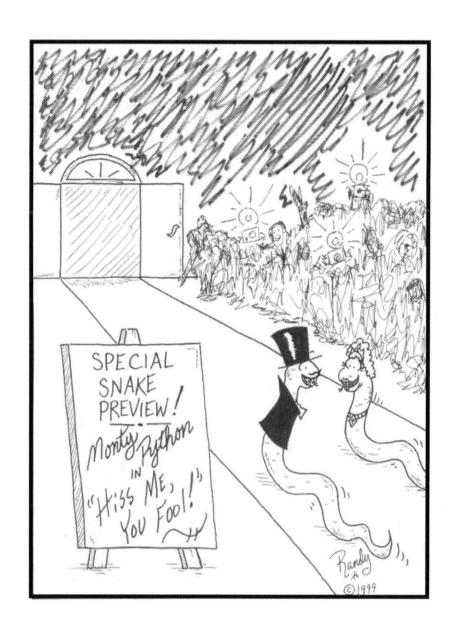

42

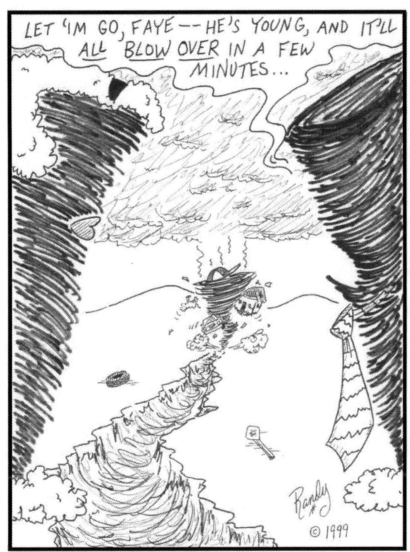

TWISTER TANTRUMS

43

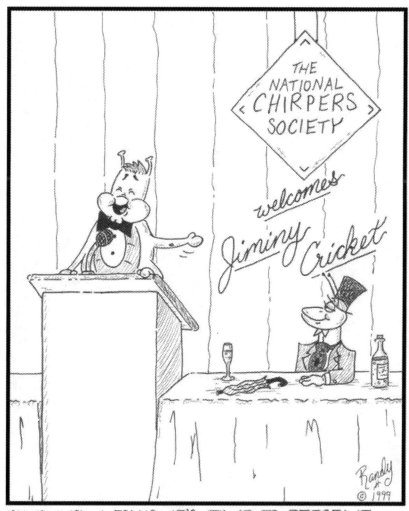

"AND NOW, FOLKS, IT'S TIME TO PRESENT OUR GUEST OF HONOR. SO WON'T YOU PUT YOUR LEGS TOGETHER FOR A SUPER GUY...!"

44

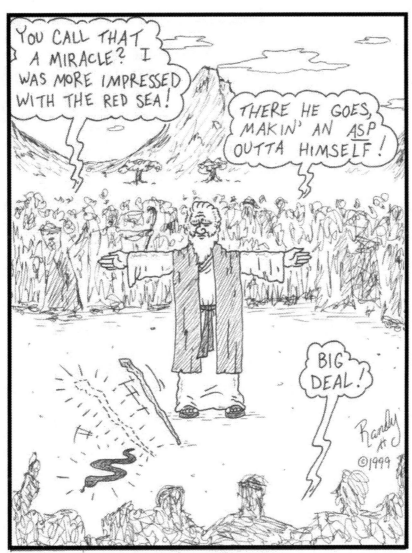

MOSES' HECKLERS

45

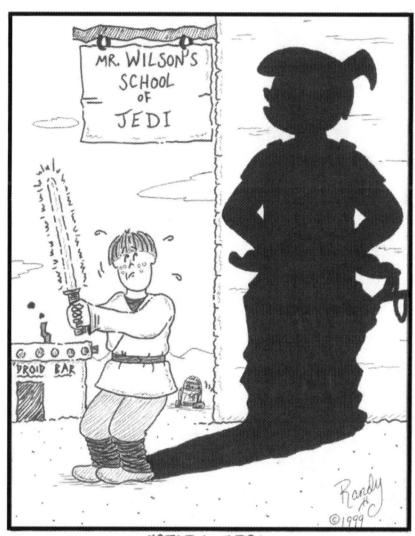

"STAR WARS:
THE PHANTOM DENNIS-THE-MENACE"

46

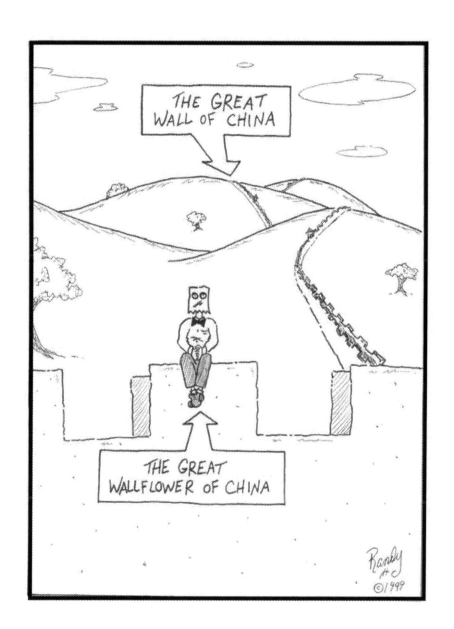

47

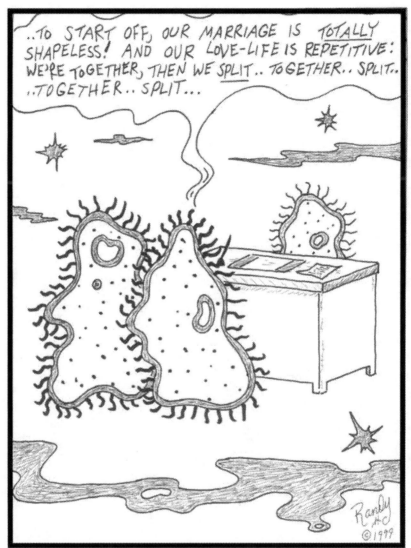

AMOEBA MARRIAGE COUNSELLING

48

49

"SO! WHICH ONE O' YA SIDEWINDERS IS BILLY THE KID?!"

50

MR. ED: THE TWILIGHT YEARS

51

SANTA KNEW THE ELVES HAD GONE OUT FOR A JOY-
RIDE THE NIGHT BEFORE WHEN HE DISCOVERED A
MINI-BRA IN THE SLEIGH...

52

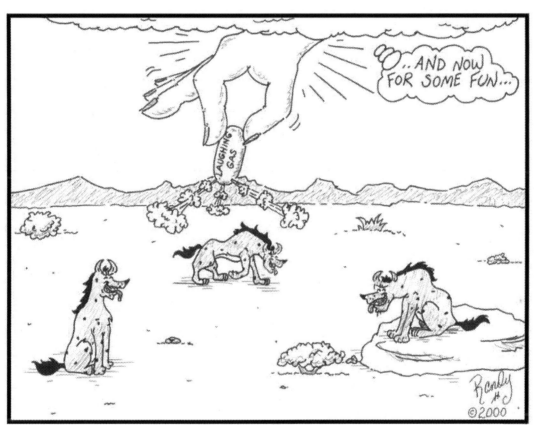

WHEN GOD CREATED HYENAS

53

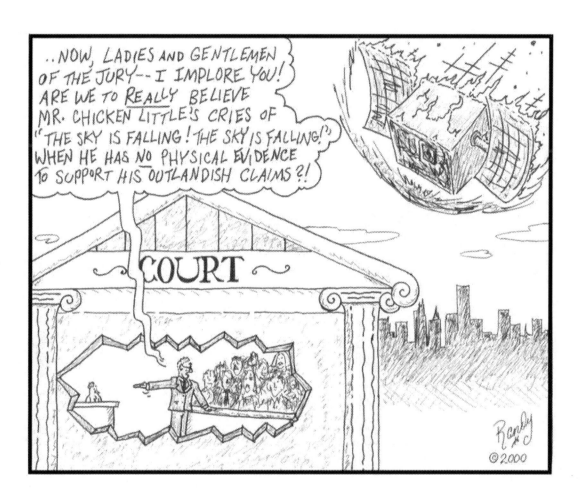

54

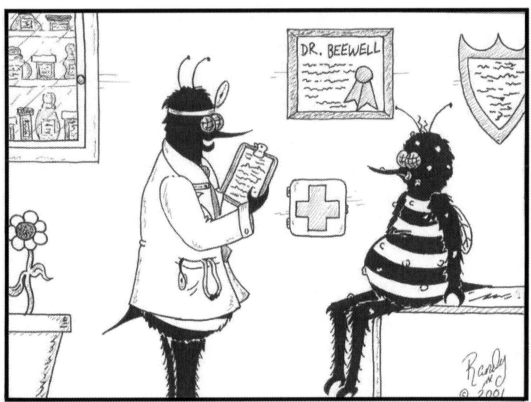

"WELL, MR. BUZZOFF, SEEMS LIKE YOU'VE CAUGHT A DANDY CASE OF THE HIVES..."

55

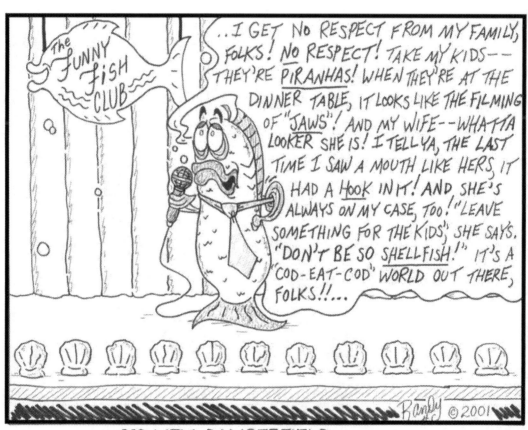

COD-NEY DANGERFIELD

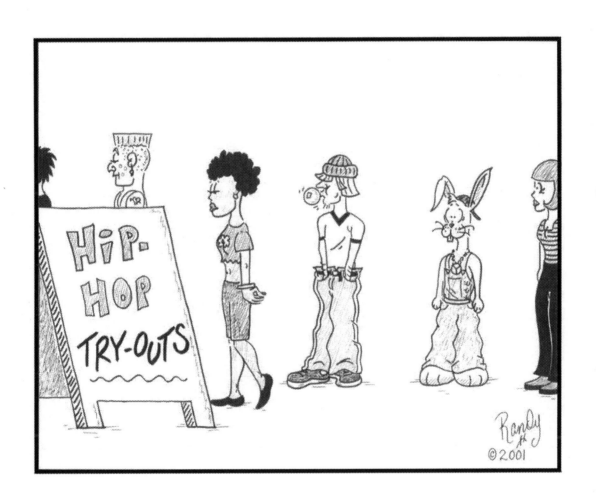

57

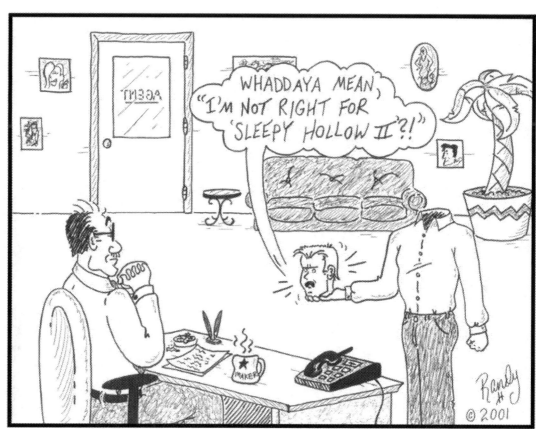

ACTOR LEONARDO DECAPITATED

58

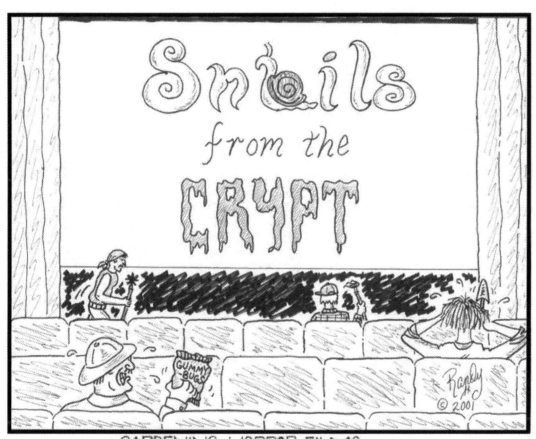

GARDENING HORROR FILMS

59

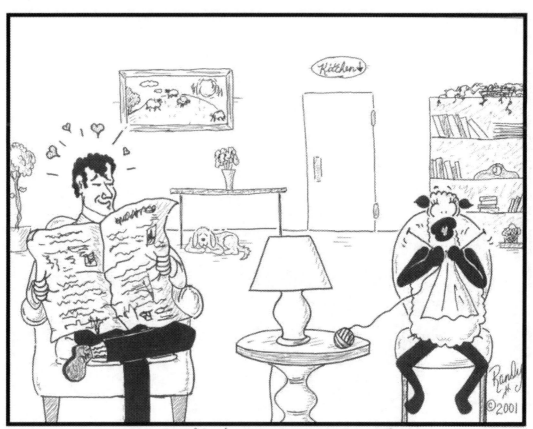

T.V.'S "MAD ABOUT EWE"

60

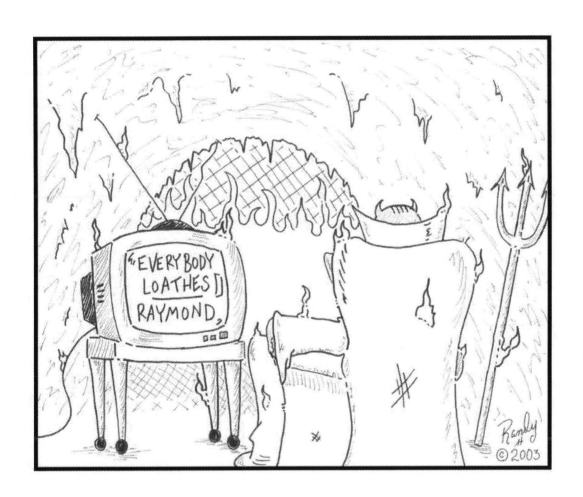

61

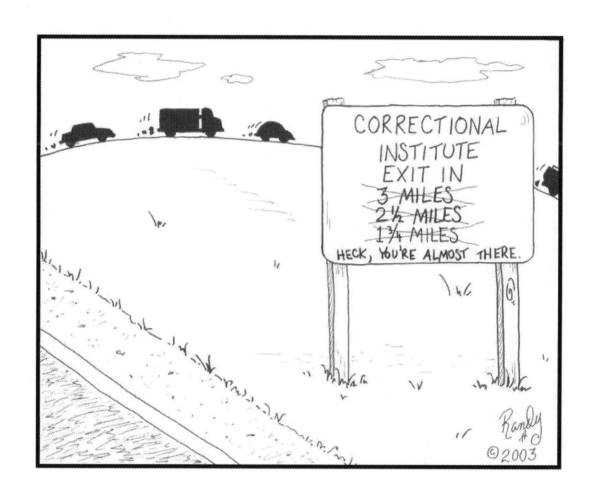

62

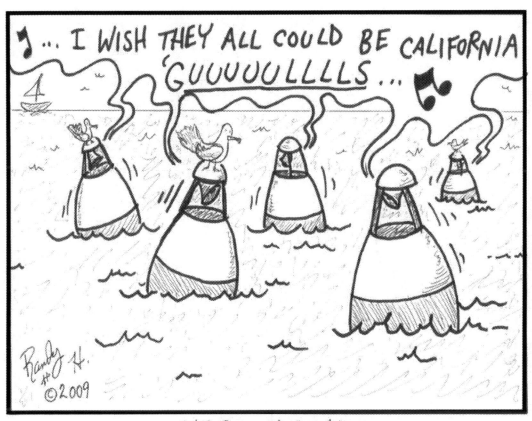

THE BEACH BUOYS

63

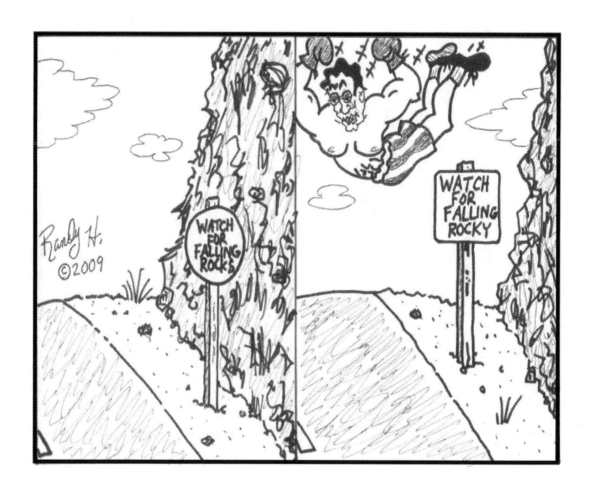

64

FLY MOVIES

65

CLOWN FISH

66

"CELL" PHONES

67

THE LED ZEPPELIN MALL

68

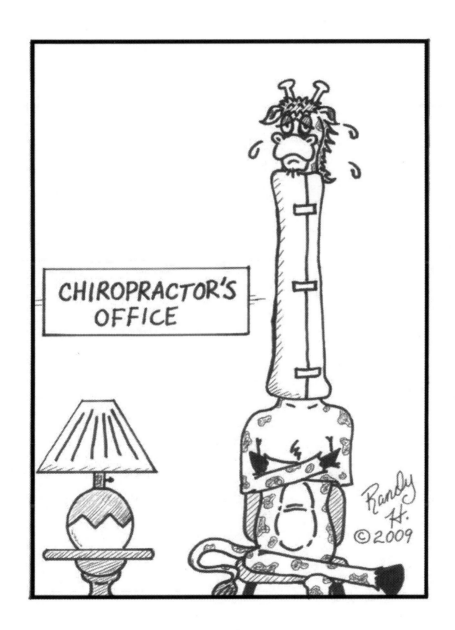

69

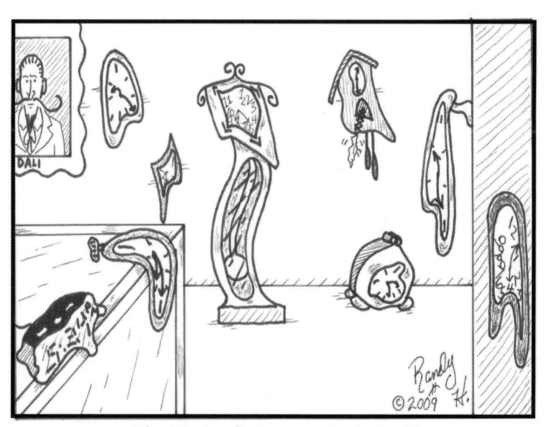

THE SALVADOR DALI CLOCK SHOP

70

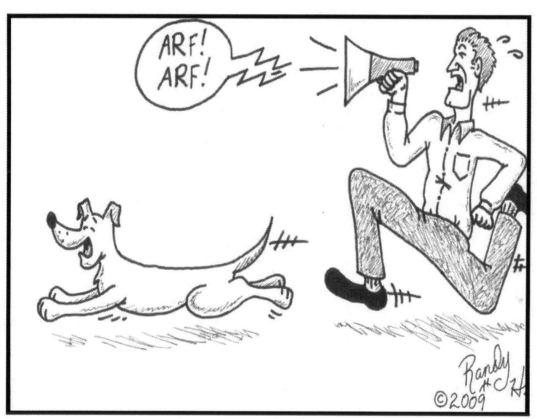

MILLI VANILLI'S DOG

71

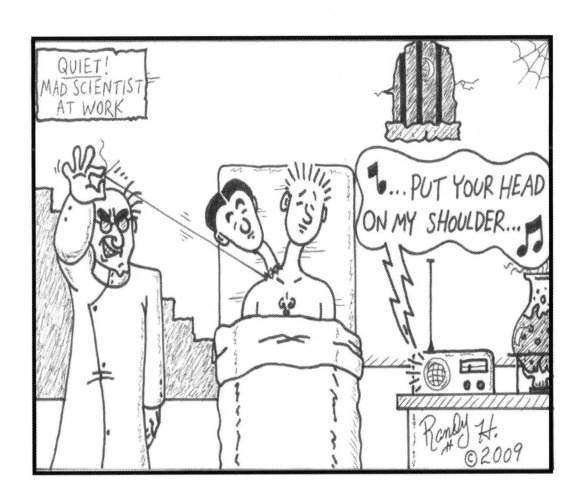

72

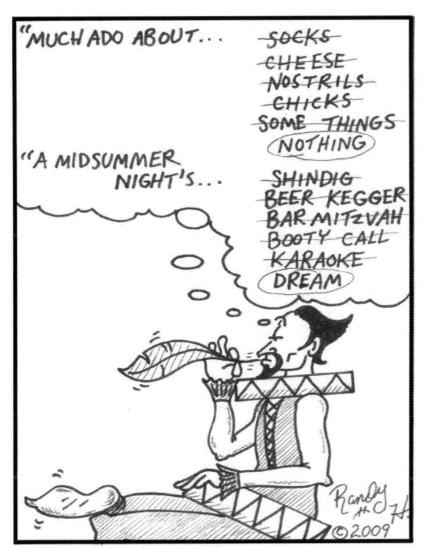

WILLIAM SHAKESPEARE TITLING HIS PLAYS

74

75

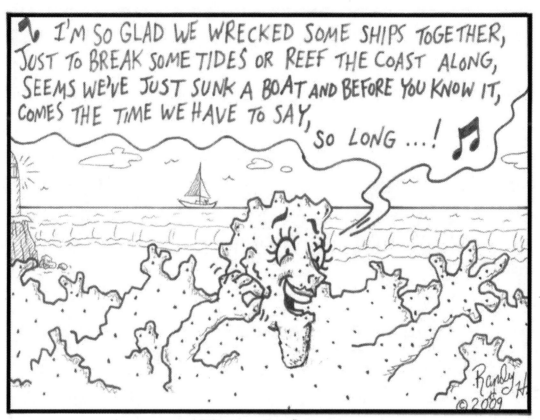

CORAL BURNETT

76

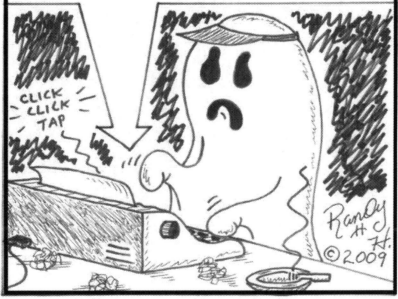

... AND SO, I CONTINUED TO FLOAT DOWN THE LONG, DARK, EMPTY HALLWAY...
WHEN SUDDENLY...
THERE APPEARED THE DISGUSTING APPARITION OF A WARM-BLOODED HUMAN! I FROZE IN MY TRACKS, AND AN ICY COLD SHIVER RAN UP AND DOWN MY SHEET...!

CLICK
CLICK
TAP

Randy
H.
©2009

GHOST WRITERS

77

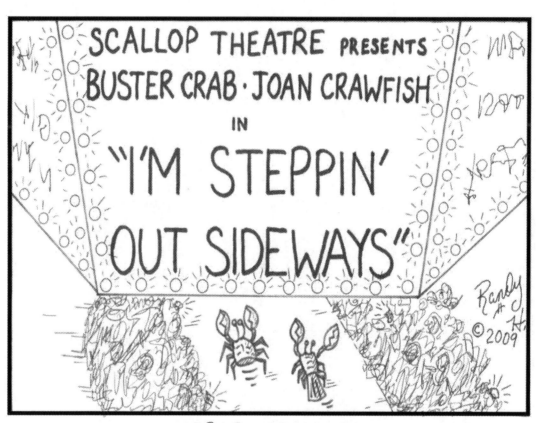

CRAB MUSICALS

78

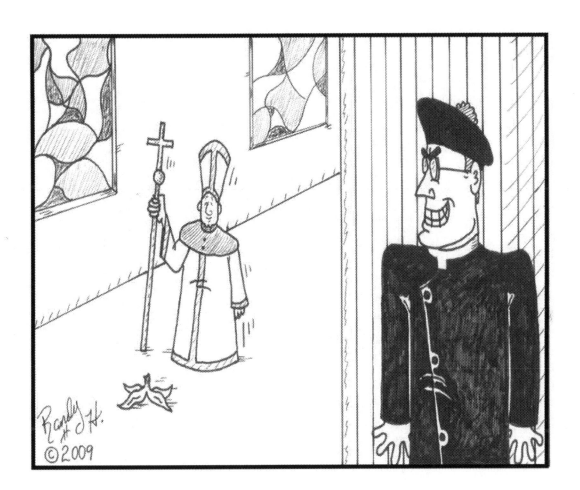

79

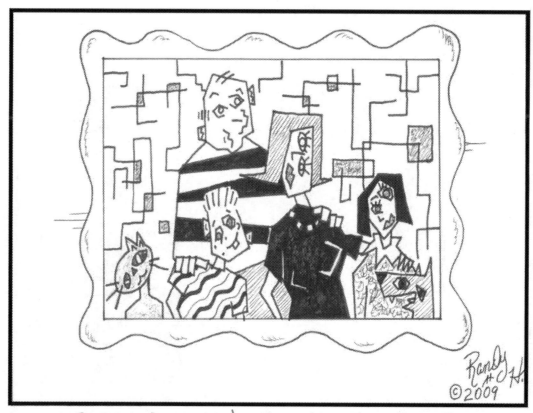

PABLO PICASSO'S FAMILY PORTRAIT

80

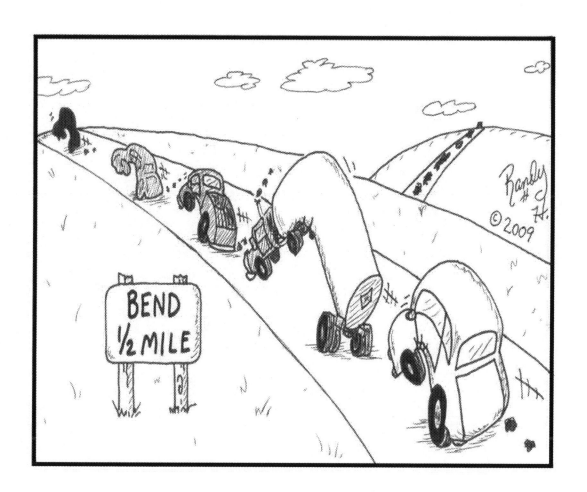

81

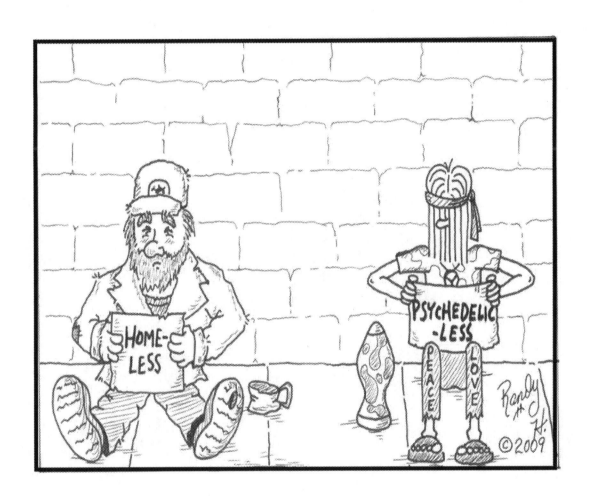

82

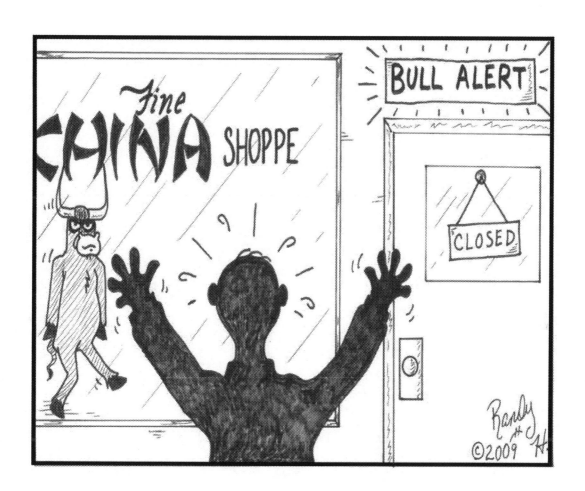

83

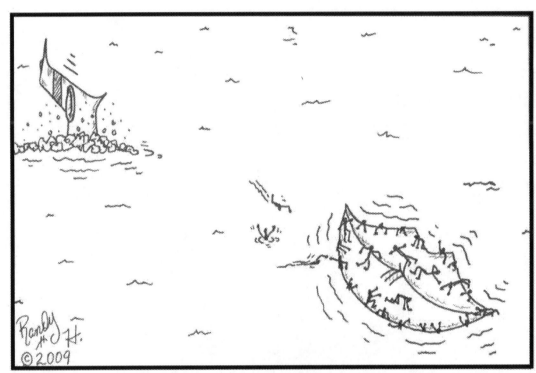

AS FLIGHT 913 SLOWLY SANK TO A WATERY GRAVE, ITS SURVIVORS WERE FORTUNATE THAT CELEBRITY PASSENGER JULIA ROBERTS' LIPS COULD BE USED AS A FLOATATION DEVICE...

84

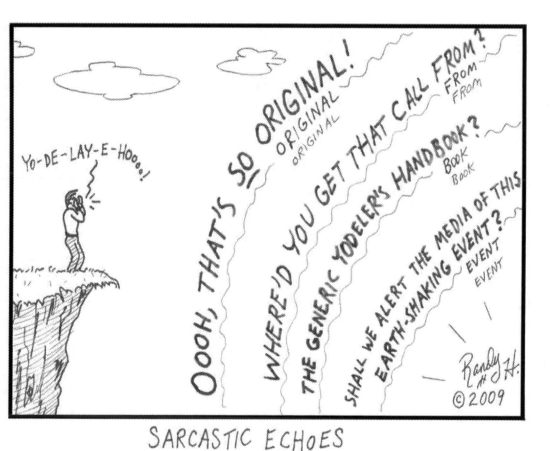

SARCASTIC ECHOES

85

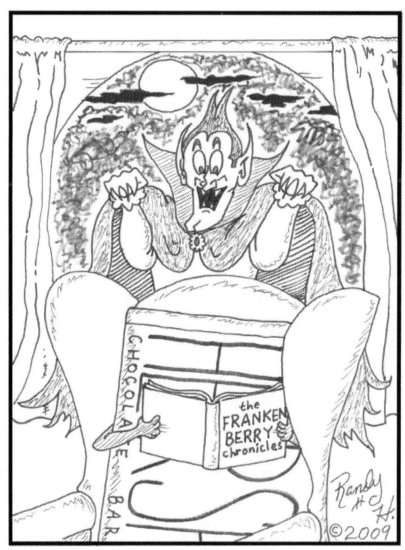

COUNT CHOCULA'S MIDNIGHT CRAVINGS

86

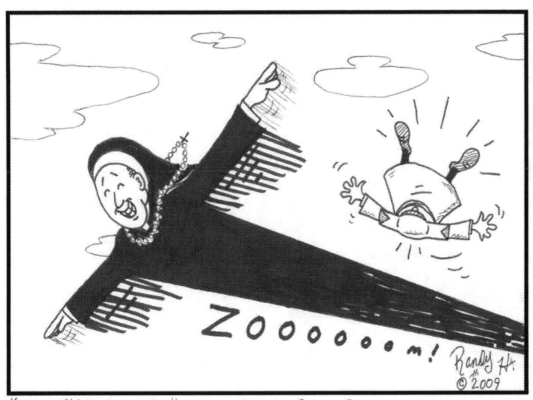

ZOOOOOOm!

"THE FLYING NUN'S" BETTER AND FASTER COUSIN, "THE FLYING STEALTH NUN"

87

THE
BROOM HILDA
INSOMNIA
CENTER
FOR
WITCHES
DEDICATED TO CURING
"NO REST
FOR THE WICKED"

Randy H.
©2009

88

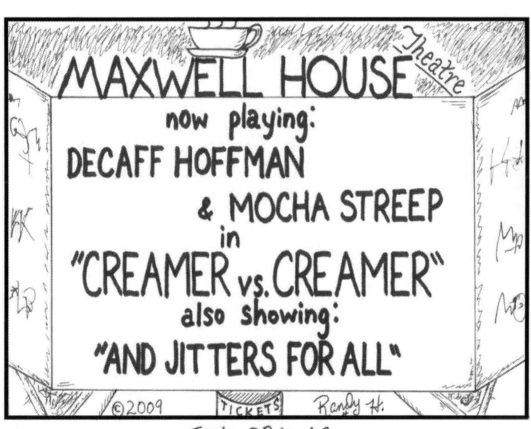

JAVA DRAMAS

89

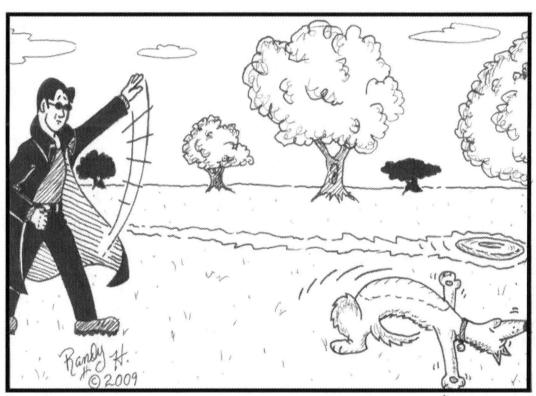

IN THIS SCENE FROM "THE MATRIX: RECREATIONS", NEO AND HIS DOG ENJOY SOME FRISBEE IN THE PARK...

90

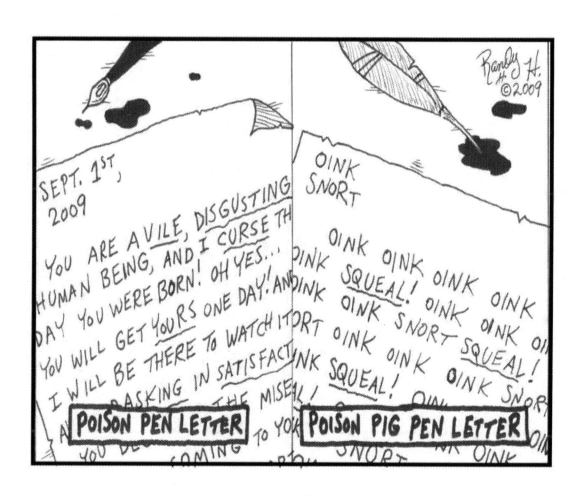

91

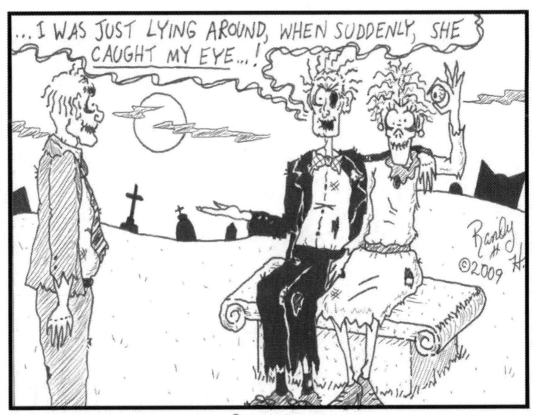

ZOMBIE LOVE

92

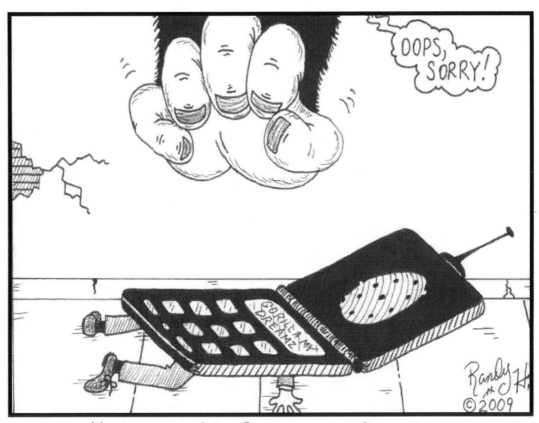

KING KONG DROPS HIS CELL PHONE

93

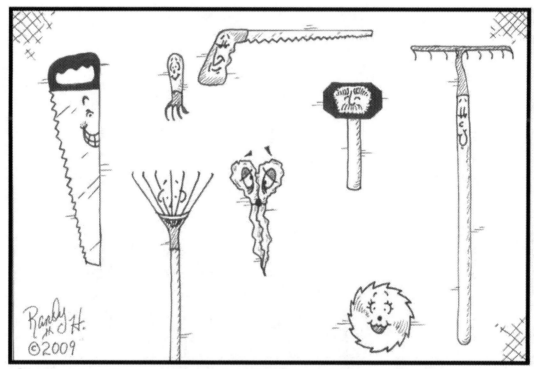

SURROUNDED BY SHINY PERFECT COMPANIONS ON
THE WALL, CUTTER THE GARDENING SHEARS SOON
REALIZED HE WASN'T "THE SHARPEST TOOL IN THE SHED"...

94

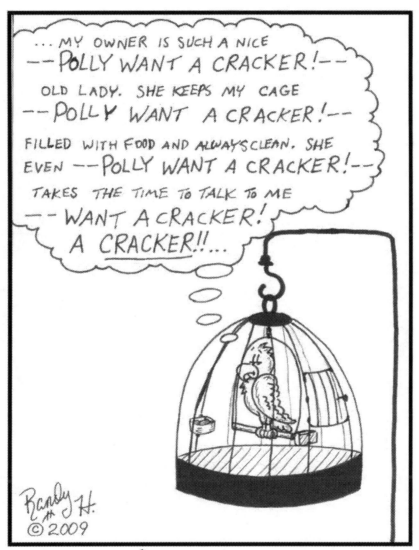

A PARROT'S TRAIN OF THOUGHT

95

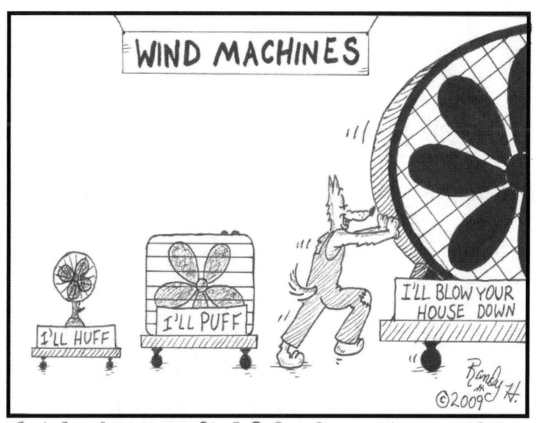

THE BIG BAD WOLF PREPARES FOR THE THREE LITTLE PIGS

96

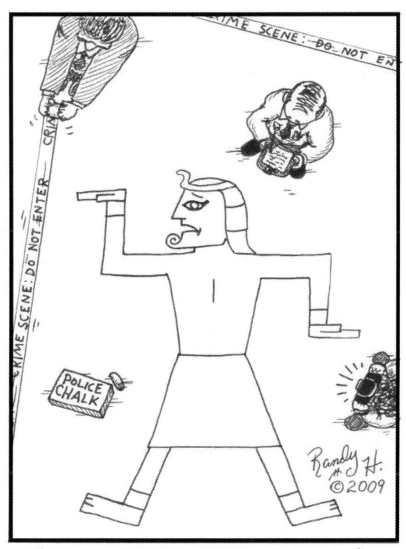

THE T.V. CRIME DRAMA "CSI: CAIRO"

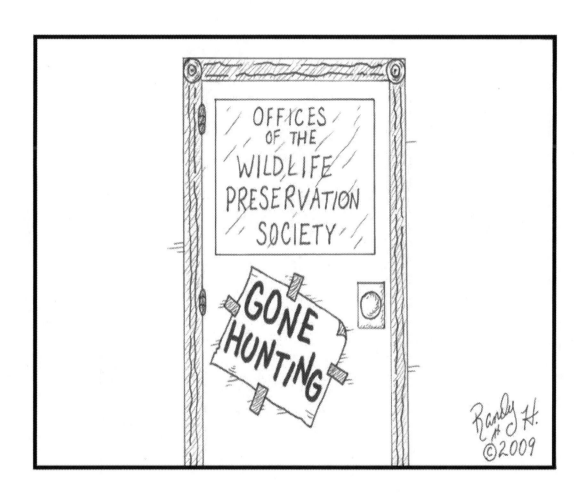

98

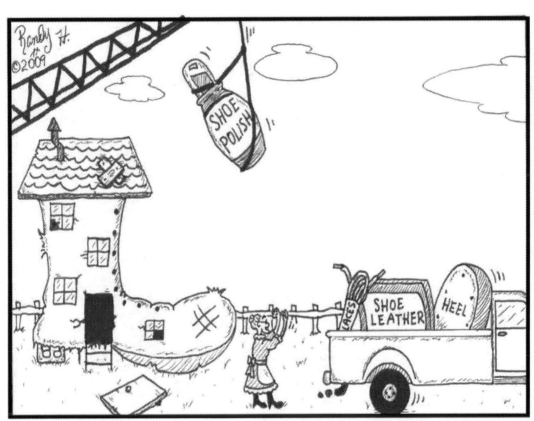

"THE OLD WOMAN WHO LIVES IN A SHOE" GETS A HOME MAKEOVER

99

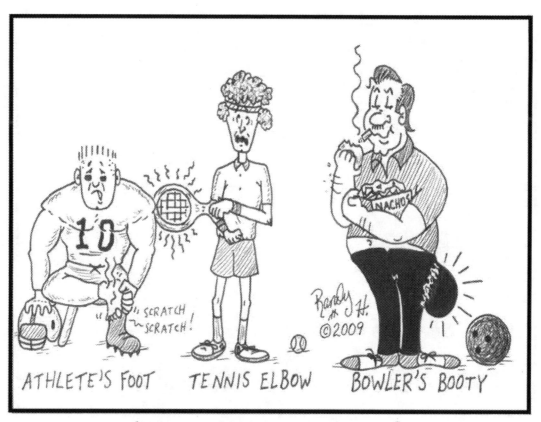

COMMON SPORTS AFFLICTIONS

100

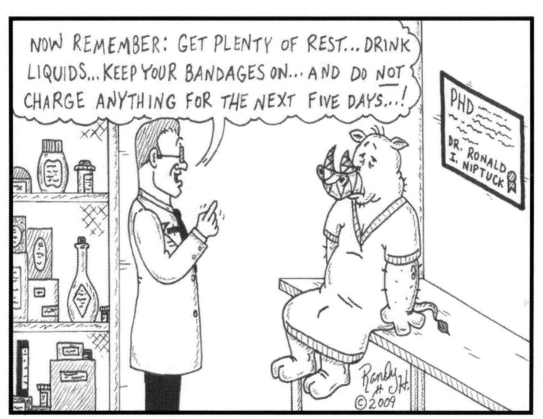

RHINO-PLASTY

101

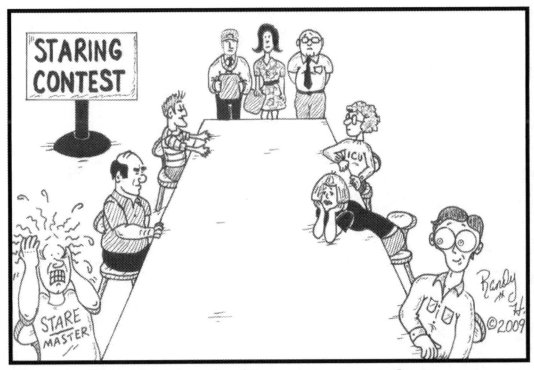

THE JUDGES BEGAN TO SUSPECT THAT SOMEONE CREATED AN
UNFAIR ADVANTAGE BY BRINGING IN A "WEAPON OF INTIMIDATION";
ELIJAH WOOD AND HIS DINNER PLATE-SIZED EYES...

102

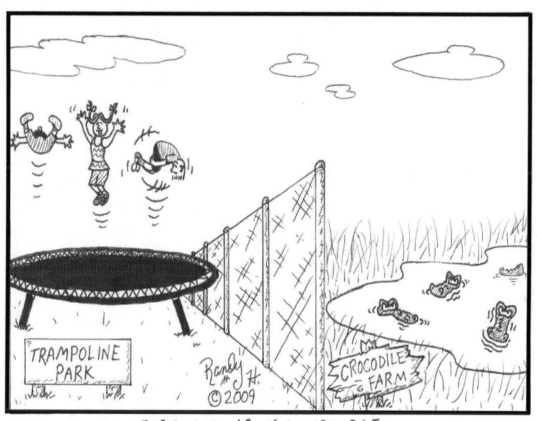

JUST ASKING FOR TROUBLE

103

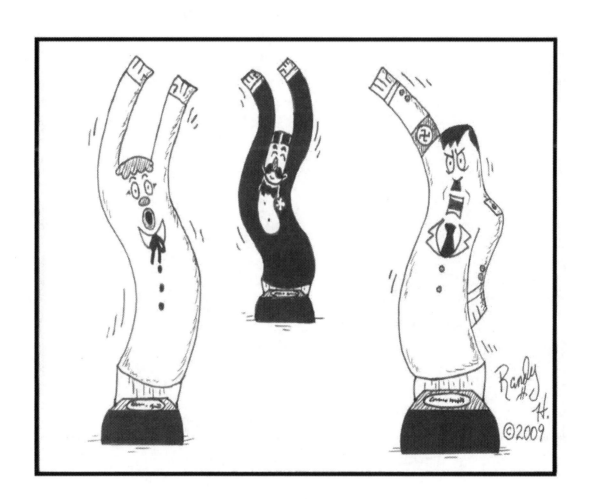

104

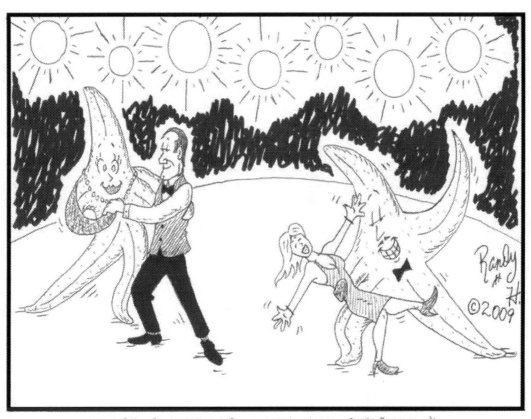

T.V.'S "DANCING WITH THE STARFISH"

105

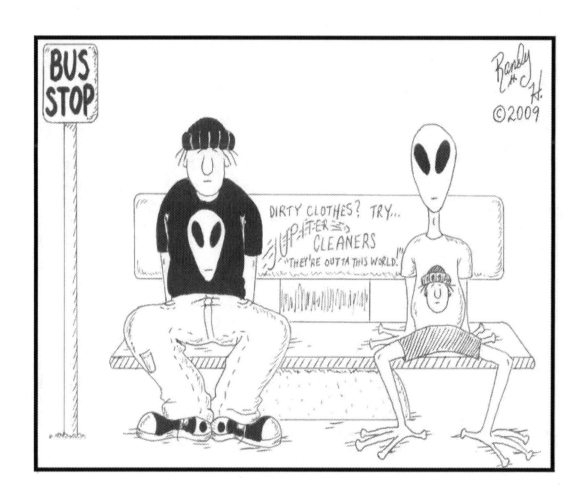

106

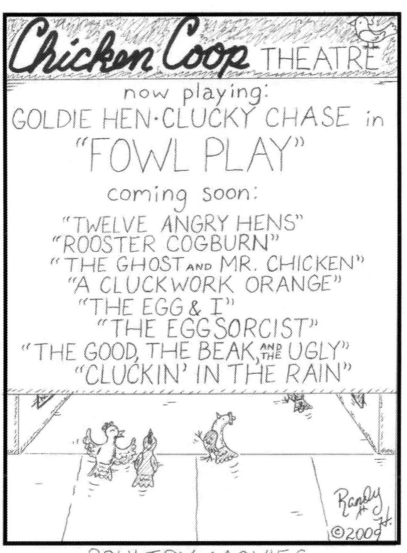

POULTRY MOVIES

107

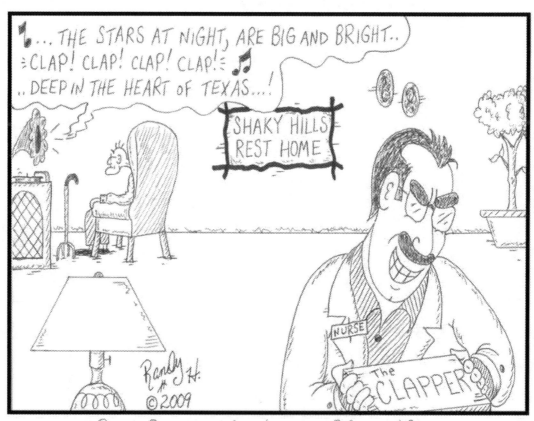

RETIREMENT HOME PRANKS

108

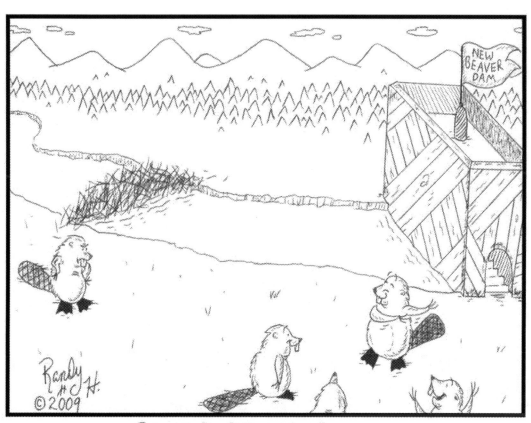

BEAVER PRODIGIES

109

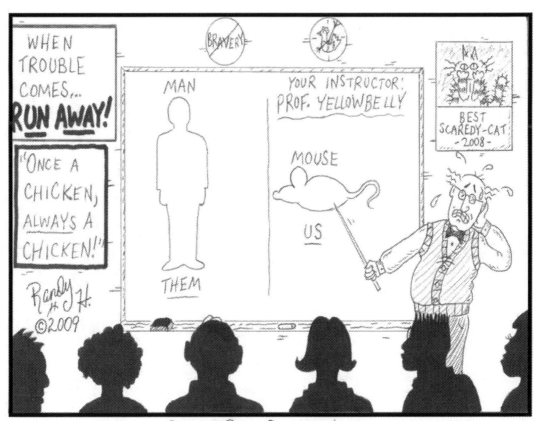

COWARD SCHOOL

110

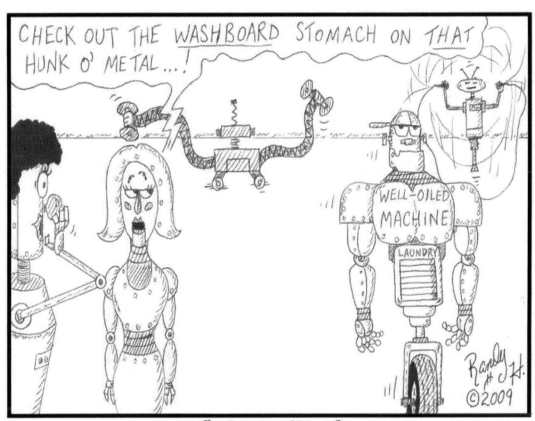

ROBOT GYMS

111

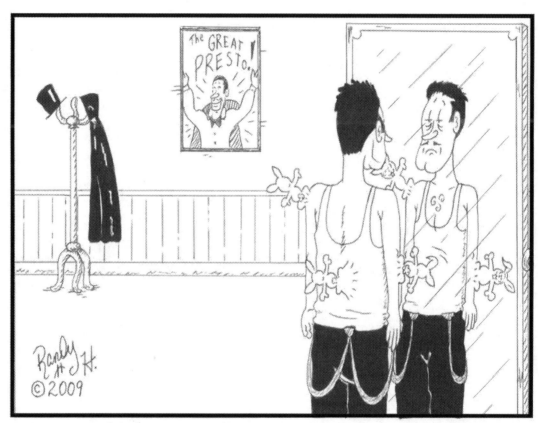

A COMMON PROBLEM AMONG MAGICIANS: IN-GROWN HARES...

112

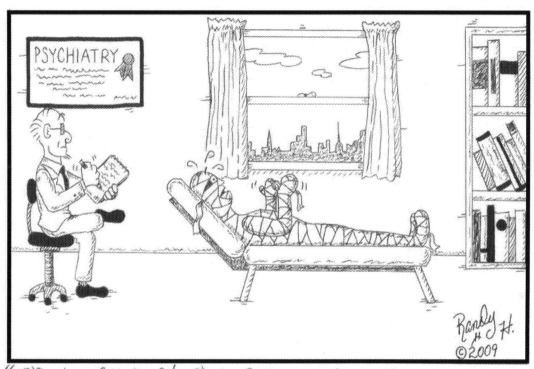

"IT'S NO USE, DOC! I'VE TRIED EVERYTHING--FIXING THE SPHINX'S NOSE--SCARING TOURISTS--BUT I JUST CAN'T SEEM TO UNWIND..."

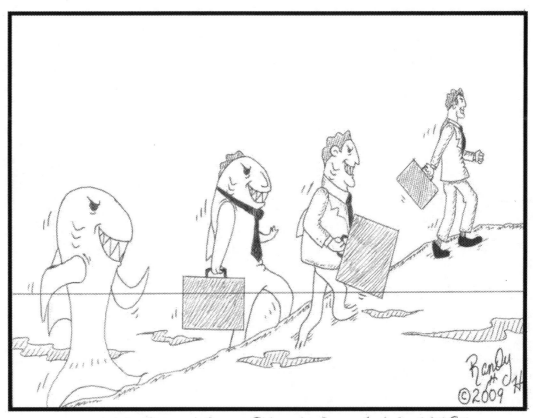

THE EVOLUTIONARY CHART OF LAWYERS

114

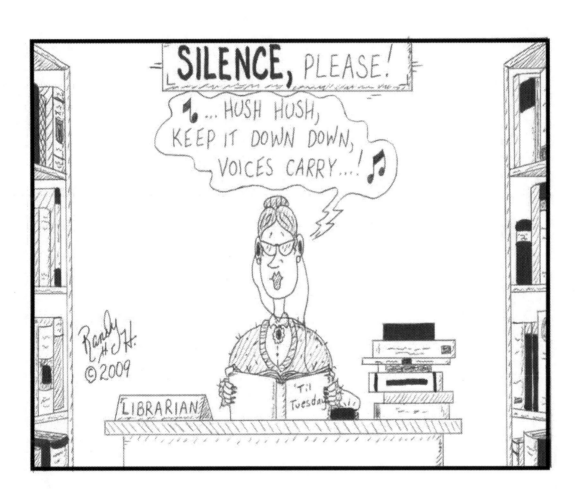

115

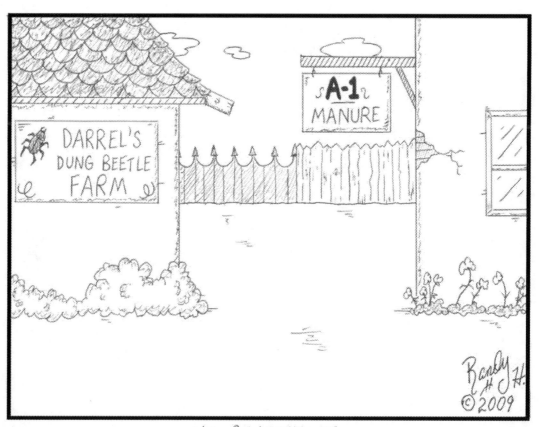

NO COMMENT

116

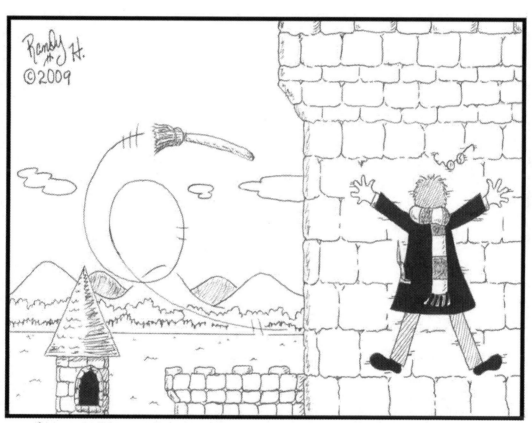

SCENE FROM "HARRY POTTER AND THE VENGEFUL BROOM"

117

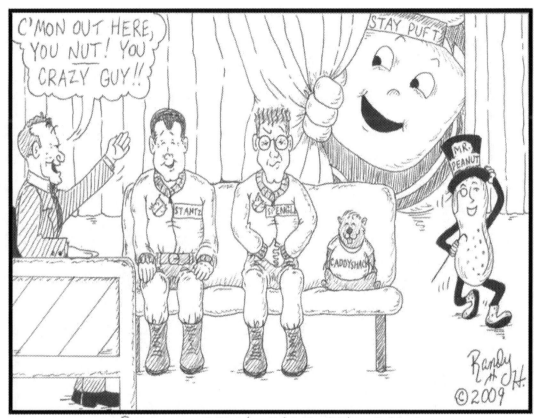

BILL MURRAY: TALK SHOW HOST

118

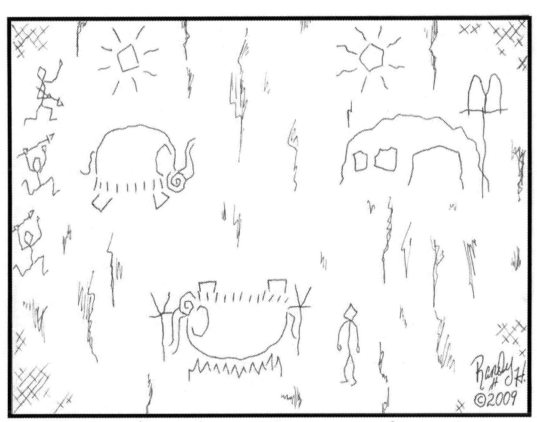

MANKIND'S EARLY CAVE DRAWINGS OF FOOD

119

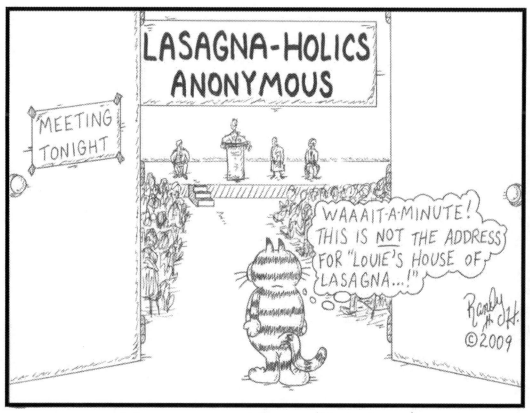

GARFIELD THE CAT'S INTERVENTION

120

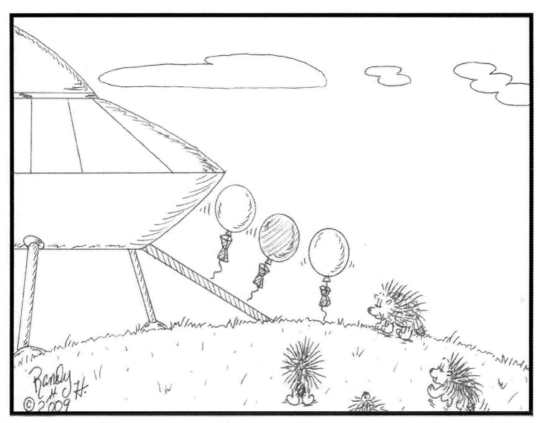

CLOSE ENCOUNTERS OF THE DELICATE KIND

121

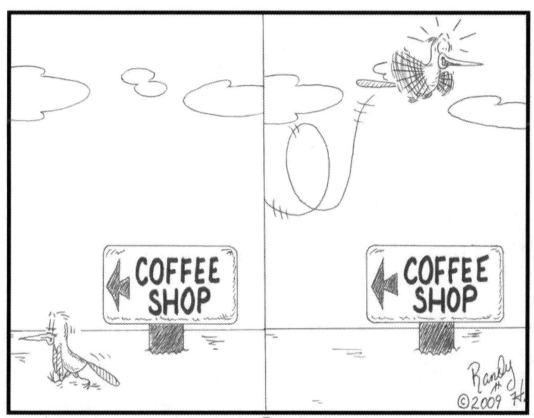

HOW HUMMINGBIRDS PREPARE FOR THE DAY

122

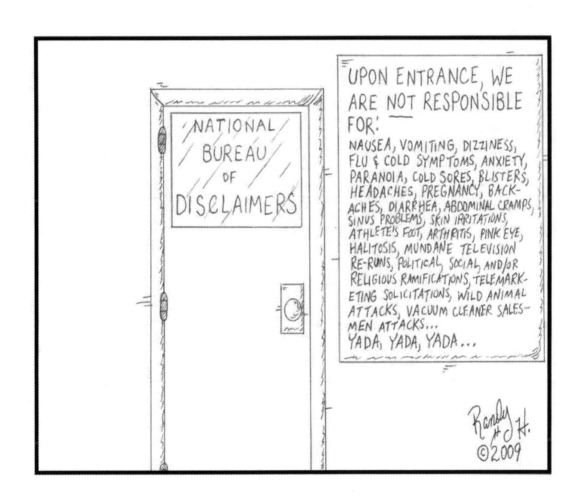

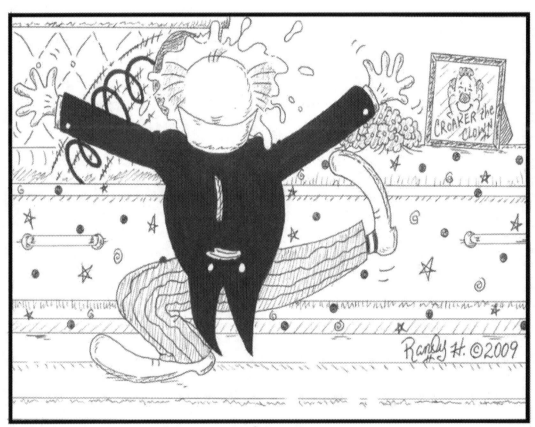

CLOWN FUNERALS

124

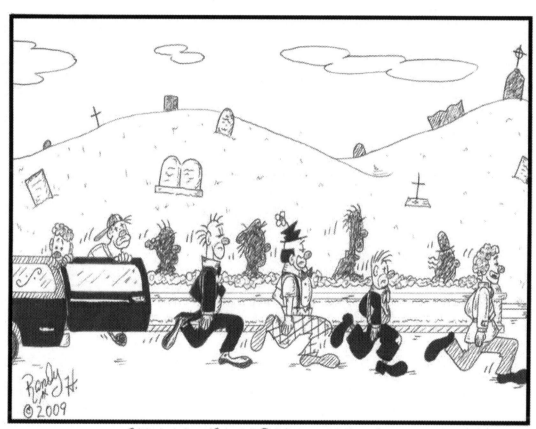

CLOWN FUNERALS, PART 2

125

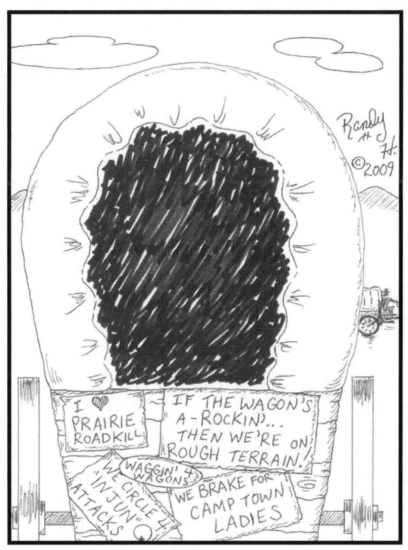

WAGON TRAIN BUMPER STICKERS

126

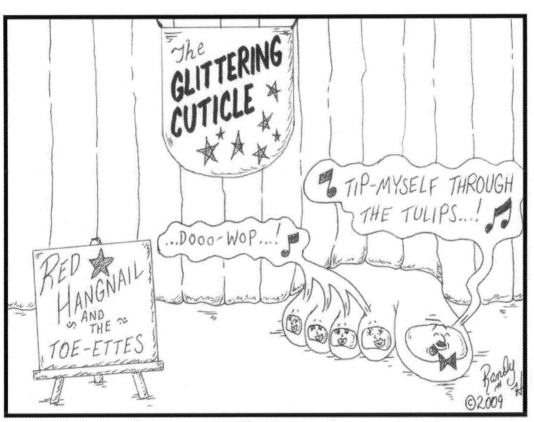

TOM THUMB'S SHOWBIZ UNCLE

127

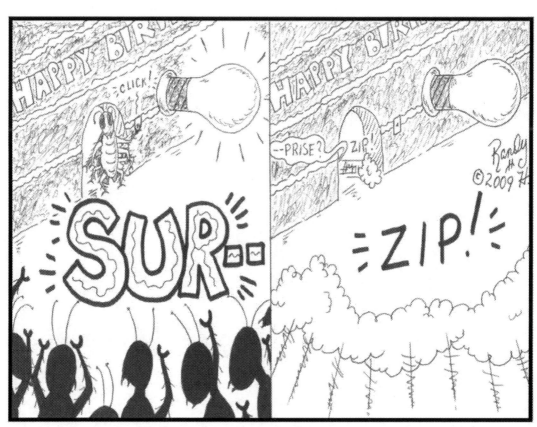

WHY COCKROACH SURPRISE PARTIES NEVER WORK

128

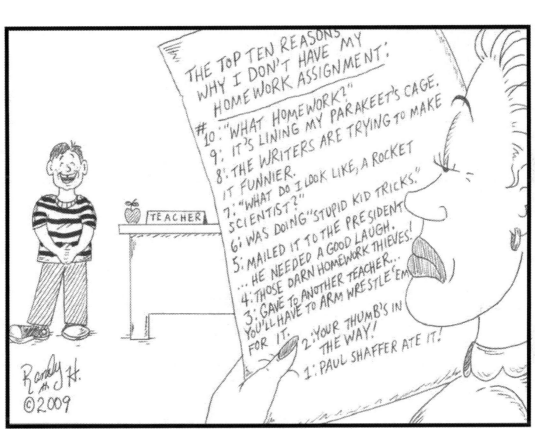

DAVID LETTERMAN'S CHILDHOOD

129

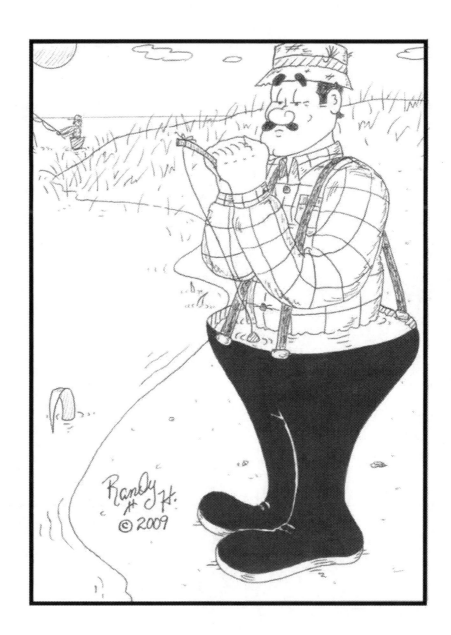

130

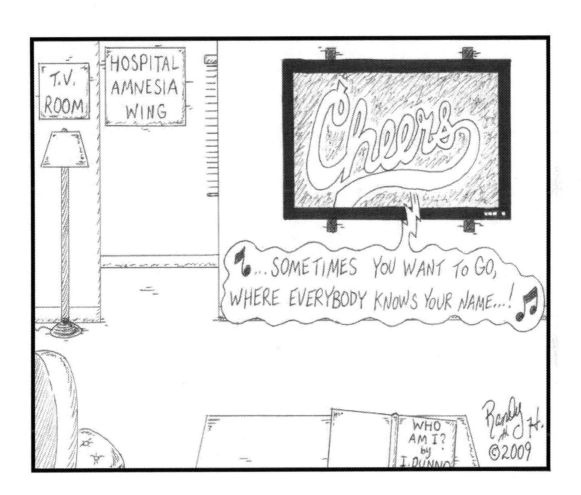

131

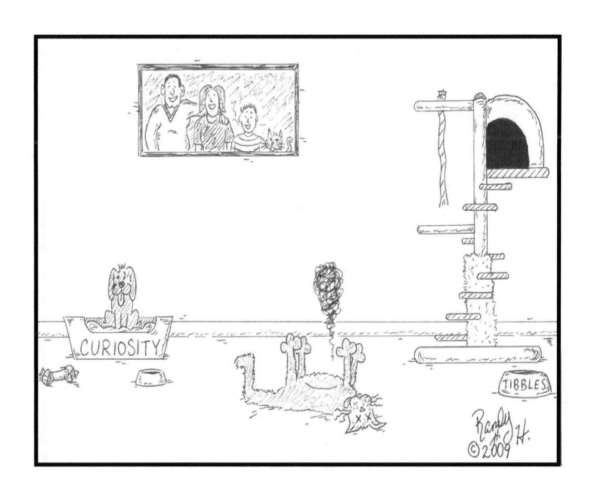

132

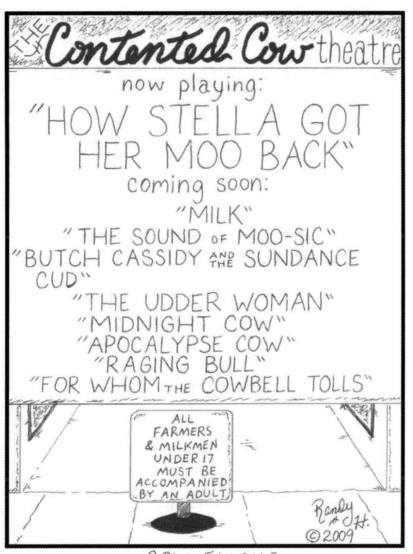

COW FLICKS

133

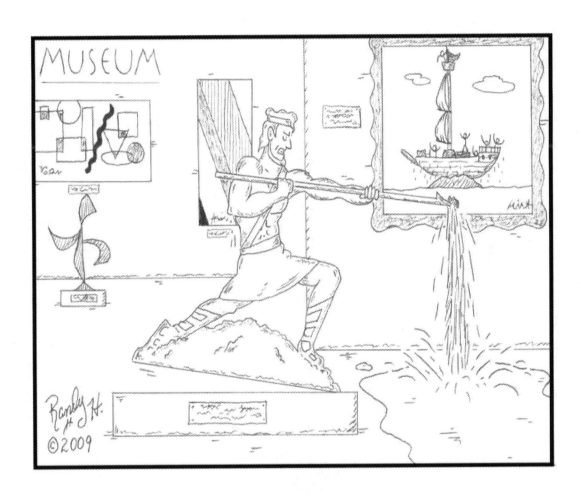

134

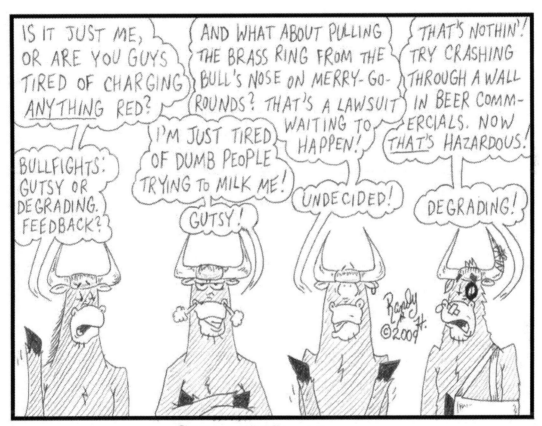

BULL SESSIONS

135

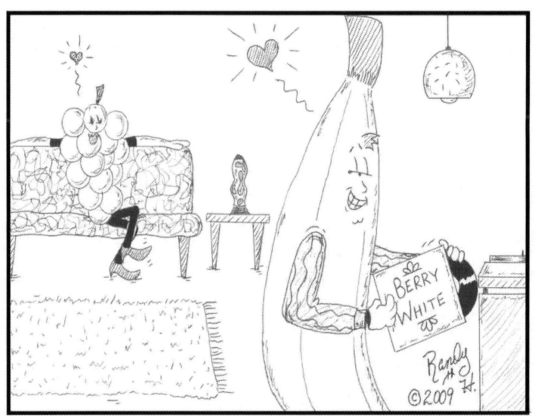

FRUIT MOOD MUSIC

136

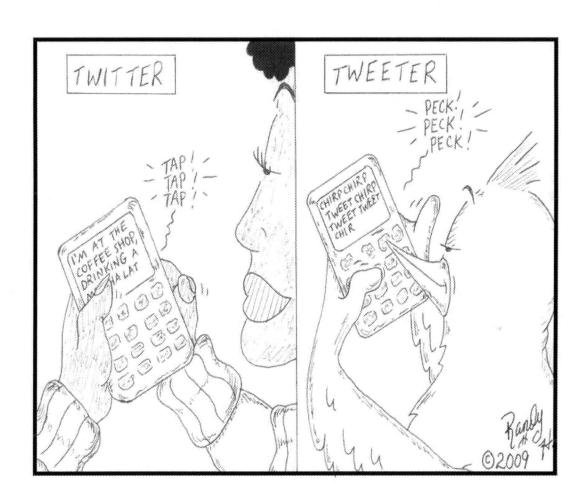

137

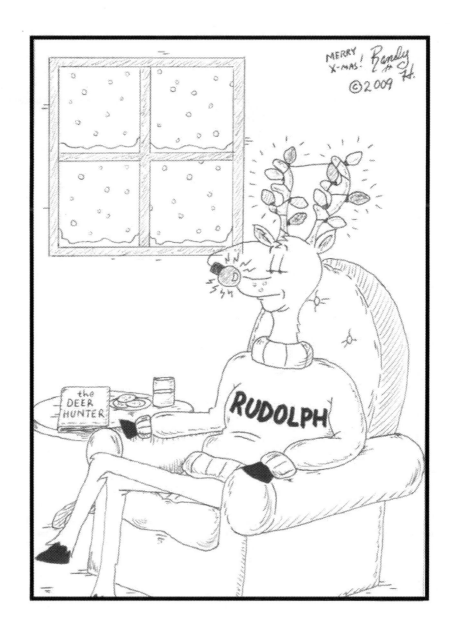

138

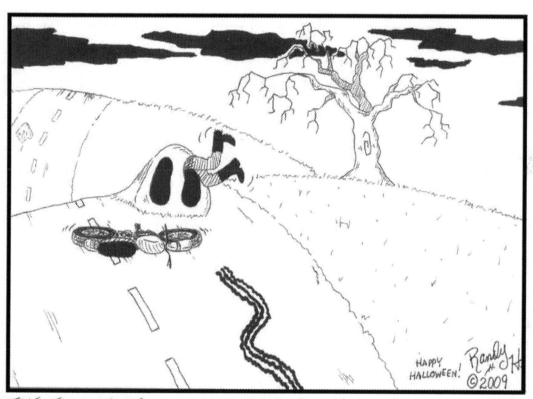

THE FOLLOW-UP TO THE HORROR FILM "THE HILLS HAVE EYES":
THE STRAIGHT-TO-VIDEO "THE ROADS HAVE NOSES"

139

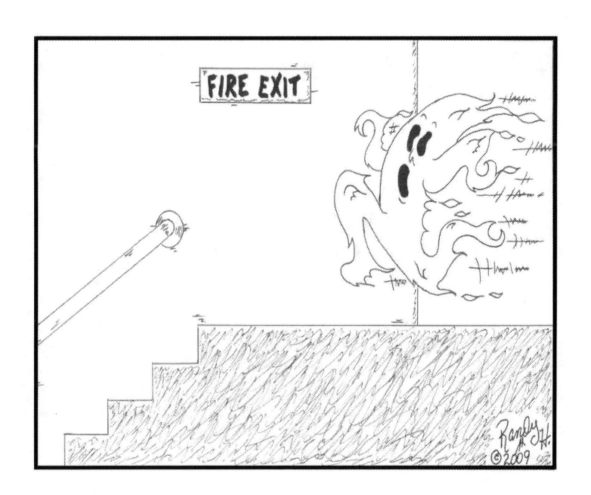

140

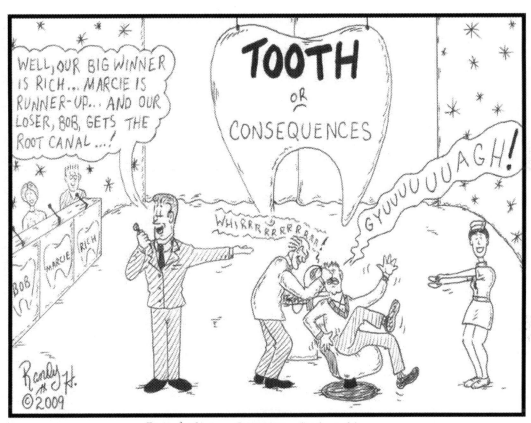

DENTAL GAME SHOWS

141

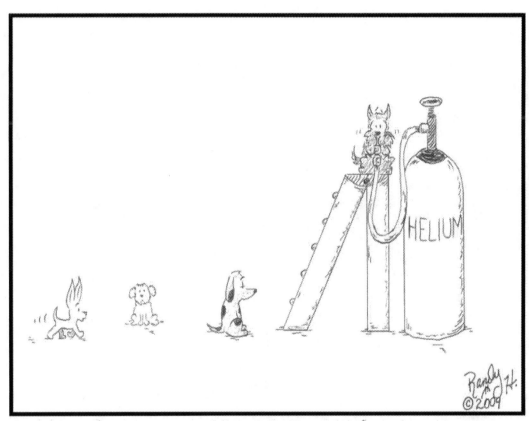

HOW SMALL DOGS GET THEIR HIGH-PITCHED BARKS

142

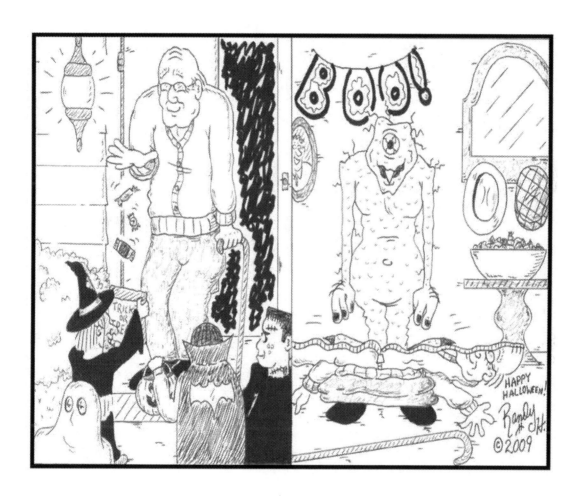

143

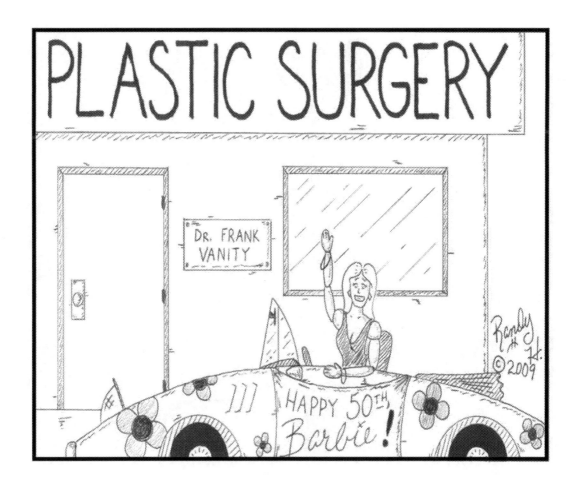

144

145

146

"...LADIES AND GENTLEMEN, WE JUST RECEIVED WORD THERE'S A MUSIC LEGEND IN OUR AUDIENCE TONIGHT. LET'S SEE IF WE CAN FIND MISS DIANA ROSS...!"

147

SID'S FATE WAS SEALED: THE MOB SENT THEIR BEST
HITMAN--EDDIE "THE ERASER" LINGUINI--TO "RUB HIM OUT"...

148

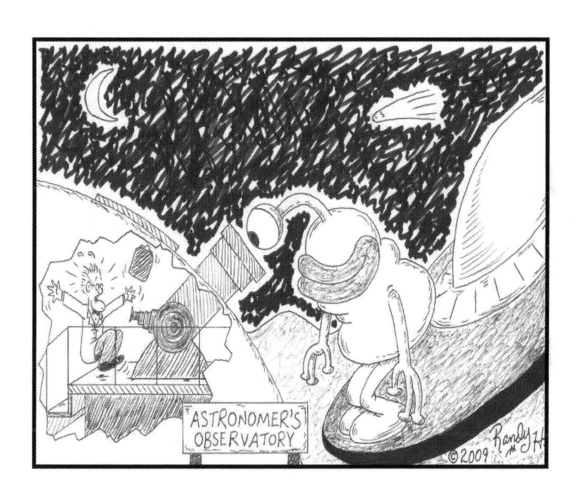

149

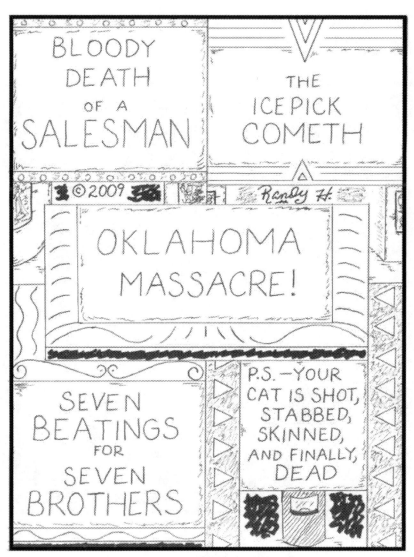

BLOODY DEATH OF A SALESMAN

THE ICE PICK COMETH

© 2009 Randy H.

OKLAHOMA MASSACRE!

SEVEN BEATINGS FOR SEVEN BROTHERS

P.S. —YOUR CAT IS SHOT, STABBED, SKINNED, AND FINALLY, DEAD

VIOLENT BROADWAY

150

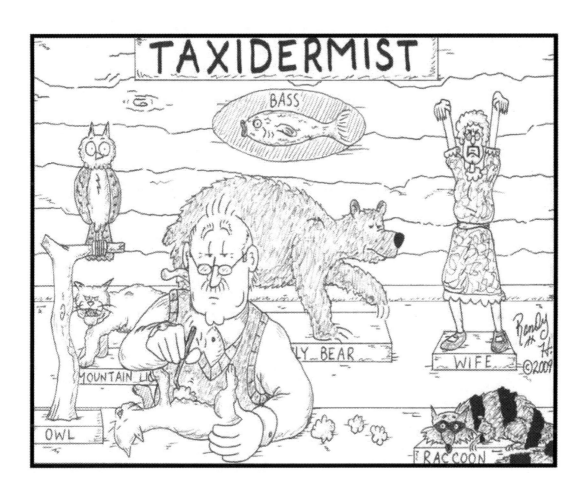

151

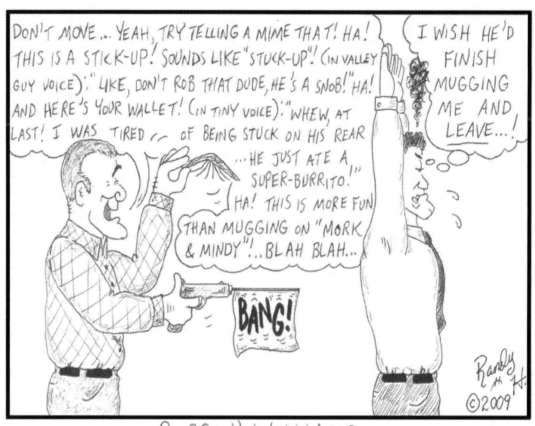

ROBBIN' WILLIAMS

152

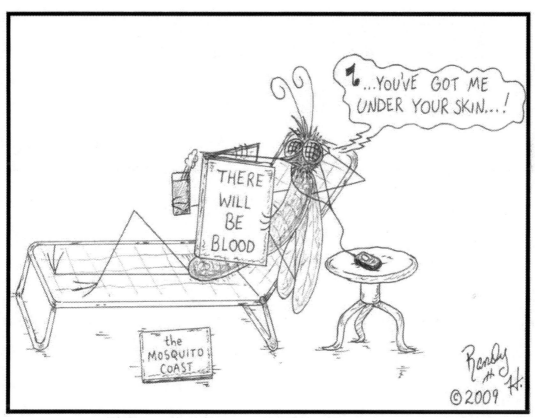

MOSQUITO LEISURE TIME

153

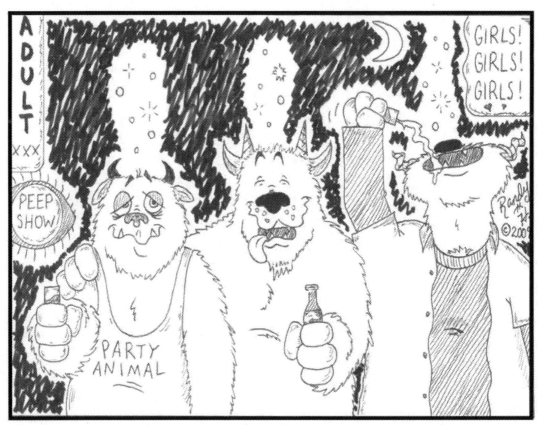

THE R-RATED VERSION OF "WHERE THE WILD THINGS ARE"

154

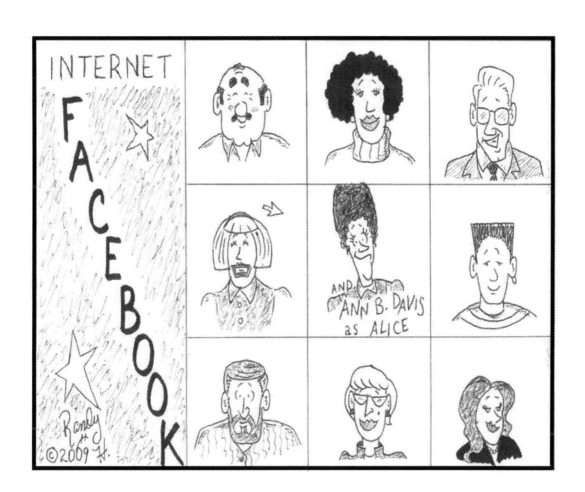

155

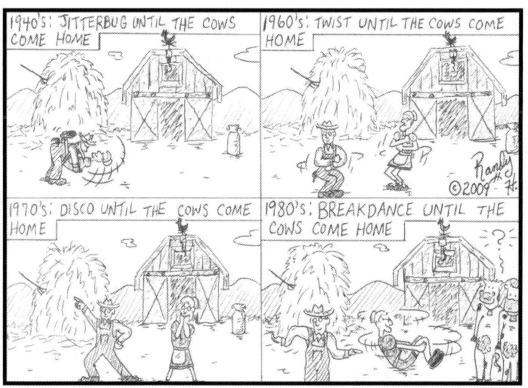

"DANCE UNTIL THE COWS COME HOME" THROUGH THE
DECADES

156

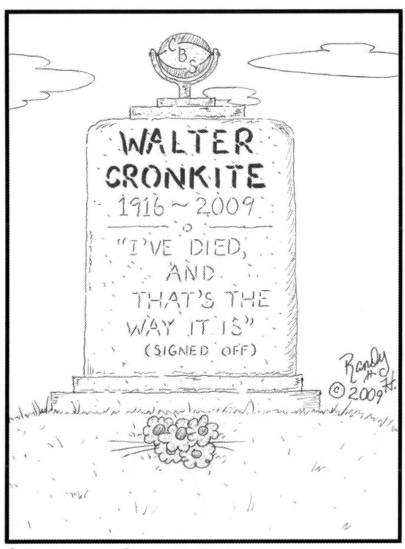

A LEGENDARY NEWSMAN'S EPITAPH

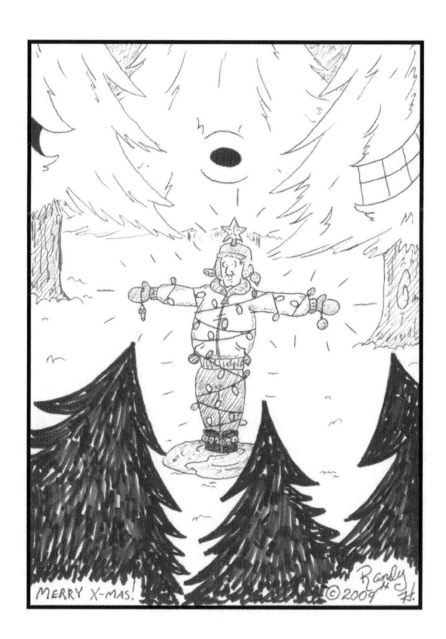

MERRY X-MAS!

©2009

158

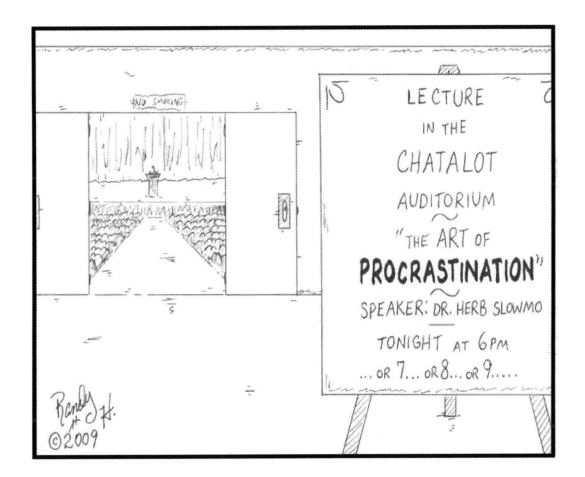

159

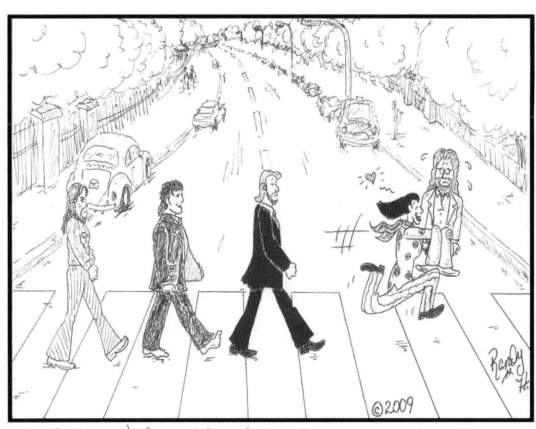

THE BEATLES' "ABBEY ROAD" COVER: THE YOKO ONO EDITION

160

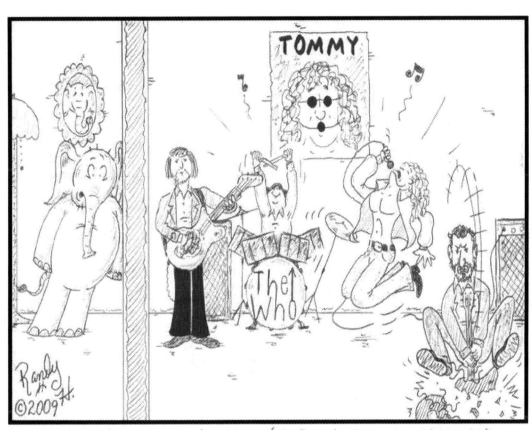

THE DR. SEUSS CLASSIC "HORTON HEARS THE WHO"

161

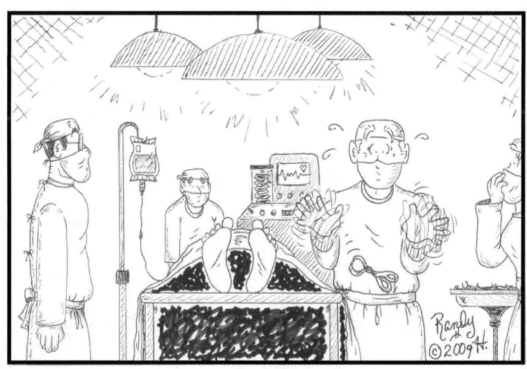

THE OPERATION WAS GOING SPLENDID UNTIL THE UNTHINK-
ABLE HAPPENED: THE CHIEF SURGEON WAS SUDDENLY STRICKEN
WITH "JAZZ HANDS"...

162

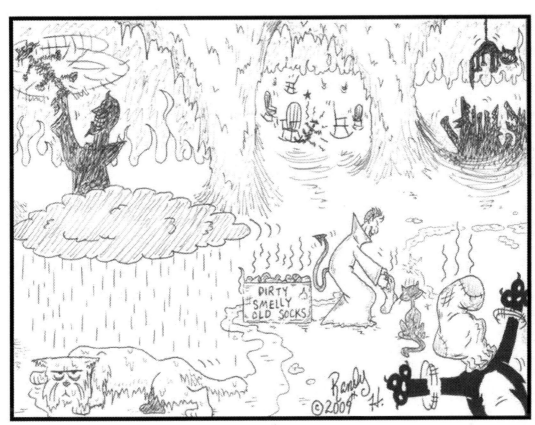

CAT HELL

163

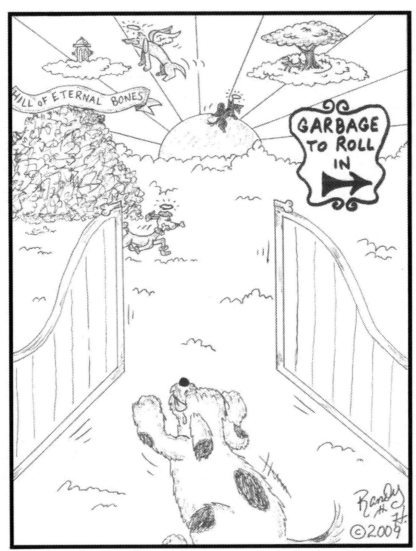

DOG HEAVEN

164

165